APERTURE

A Deepening Vision

Midway through his life, Josef Sudek found himself confronted by the inferno of history, as World War II and its aftermath poured forth and engulfed his homeland. Like Dante, Sudek passed through the horrors to find visions of enduring beauty.

"A Deepening Vision," the second issue of *Aperture* to be devoted entirely to Sudek and his work, encompasses the second half of his life. During the Nazi occupation of Czechoslovakia in World War II, Sudek retreated into the wooden shack in Prague where he lived and worked. There he began to make the still lifes and pictures of the small world just beyond his window that comprise so much of his later work. He also moved both outward into the countryside, and inward, ending his long career with an epic autobiographical cycle, "Labyrinths."

"Music keeps playing" was one of Sudek's favorite phrases, and music—especially by two of his favorite composers, his fellow Czechs Anton Dvořák and Leoš Janáček—pulses through these photographs. In these most often lyrical, at times dissonant, compositions can be seen not only the rhythms of these composers but those of Czechoslovakia itself, of a *mitteleuropa* that remained a haven of cultured sophistication despite the vicissitudes of history.

With this issue, *Aperture* completes its unprecedented celebration of Josef Sudek's sixty-five years of photographs. Without the devoted assistance and advice of Manfred Heiting and Anna Fárová, especially, this extraordinary effort would never have been consummated.

This and the previous issue of *Aperture* appear in conjunction with a retrospective of Sudek's work at the Philadelphia Museum of Art from March 3 through May 6, 1990.

D1088460

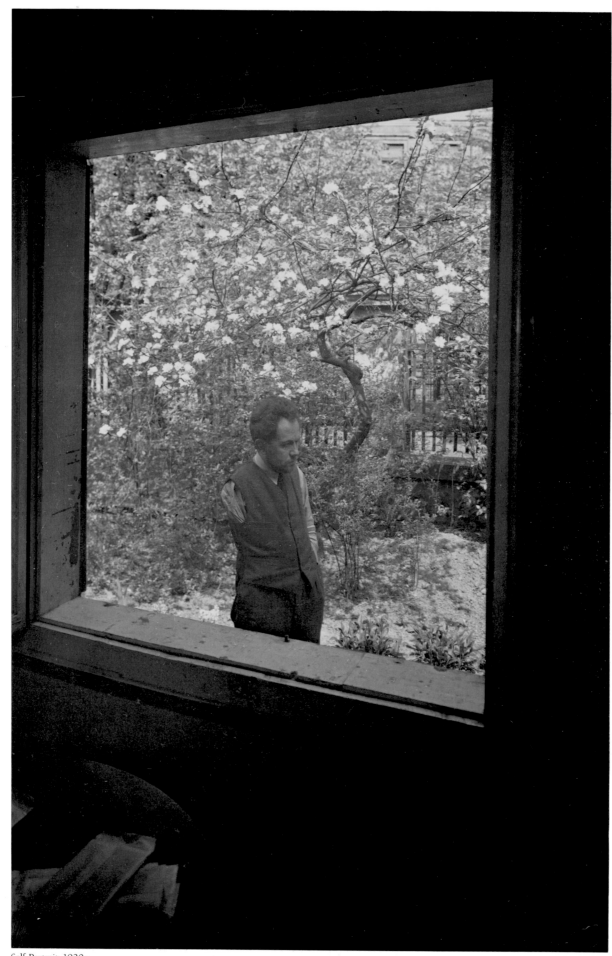

Self-Portrait, 1930s.

A Deepening Vision

By Anna Farova

If you take photography seriously you must also get interested in another art form. For me it is music. This listening to music shows up in my work like a reflection in a mirror. I relax and the world looks less unpleasant, and I can see that all around there is beauty, such as music.

Josef Sudek needed to tap every possible source of beauty as the 1930s drew to a close, and his homeland fell victim to a savagery unequalled in its long bloodletting history.

Czechoslovakia was created as a democratic republic by the victors of World War I, and it was sacrificed in 1938 by its "allies"—Great Britain and France—in an attempt to preserve peace. The Munich agreement of September 1938 ceded to Nazi Germany all districts of Bohemia and Moravia with a German population of fifty percent or more. As President Beneš resigned and left the country in exile, Poland and Hungary also received portions of Czech territory. In the month after Munich, Czechoslovakia lost one third of its population; after six months, the defenseless remainder was declared a Protectorate of the Third Reich. In March of 1939, German troops marched into Prague.

Hitler permitted the sham of a Czech president and cabinet, but power was wielded by the "*Reichprotector.*" Of several who held this viceregal position, the most notorious was Reinhard Heydrich, whose assassination in 1942 unleashed furious reprisal. The Czech economy was plundered for the Nazi war machine. By scores of thousands, Czech patriots were deported to concentration camps, impressed into slave labor, or executed. Ninety percent of Czech Jews were annihilated. In the Old Quarter, a centuries-old vibrant Jewish community had once earned Prague the title of the "Jerusalem of Eastern Europe." Here, Nazi occupiers designated the old Jewish Museum as a museum of an extinct race, filling it with treasures confiscated from synagogues and private homes across the country.

Sudek knew the horrors of war from his soldiering youth at the Italian front, but he had survived the carnage with the gusto and conviction that characterized his entire life, believing that no matter what, "the music keeps playng." As the nightmare of World War II descended upon Prague, Sudek, for the most part, retreated into his studio and into his art. During this period, his work became completely independent of all trends, and instead, spun magically along its own trajectory.

While photographing paintings in a gallery sometime around the beginning of the war, Sudek discovered a photograph dating from about 1900. Admiring the reproduction quality, he realized it was a contact print. From that time on, except for some of his commercial work, he rarely made en-largements again. As when he first experimented with the process from 1918–22, contact prints were closest to Sudek's ideal of the photographic image. Fine grain, sharp contrasts and delineations didn't interest him, and he began to use tinted papers which enhanced the slightest gradations of tonality, while retaining the blurry contours of his forms. The images deepened, dark tones became almost unintelligible and shadows merged with the blackness of the borders.

Sometimes, he would make the borders white, entirely altering one's sense of the photograph's space, as did the placement and size of the image on the paper, and whether or not the paper was cut or torn—all new considerations for Sudek. Yet it was not *l'art pour l'art*. He was simply subjecting his photographs to the same scrutiny as his subject matter. Whereas he revealed St. Vitus, for example, in all its manifestations (almost in terms of its changes, its cycle of variations), so he subjected his photographs to the same exploration, presenting the images in all possible guises, and in this way, rendering the objective reality he valued so dearly.

In 1940, Sudek discovered yet another point of view through the glass pane of his studio window, into the fog, mist, trees and hidden mysteries (not to mention Božena's interminable laundry) of the garden, and then back inside, to the ever-changing tableaux of his window ledge. This cycle juxtaposes two worlds, inner and outer, separated, united and mediated by the ever-present glass. Although one might interpret this as a "realist's" return to romanticism, another reading could be that as Sudek focused on his own, self-created, immediate environment, he moved closer to representing his inner being—windows to the soul—and approached a truer realism, or as Apollinaire had originally described this condition in 1917, "a kind of *sur-réalisme.*"

The window ledge became a stage for another kind of narrative, a theater of ordinary objects: an apple, or a piece of crumpled paper—anything could crystallize into an extraordinary still life—a term which for Sudek had an enchantingly literal meaning Sudek used to say that like Hans Christian Andersen, he desired to get at what was beyond the objects themselves. He created a world where the objects' possibilities seemed limitless, where strange juxtapositions cast them into unexpected realms, but where their references, at the same time, were also specific, often intimate.

In a sense, Sudek began this rather ethereal juxtapositioning early in his career, and on a grand scale with his photographs of St. Vitus Cathedral. Within its immense interior, he had revealed spiritual majesty fused with a millenium of haunt-

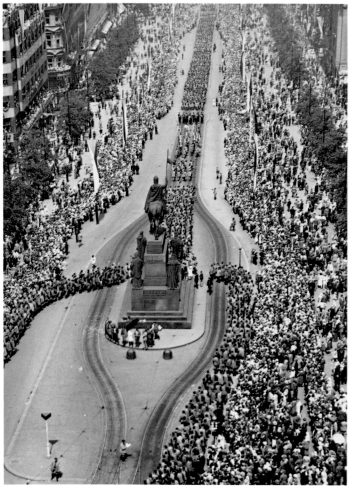

Josef Sudek, Wenceslaus Square.

ing presences: statuary, architectural detail, and workmen's debris. That vision reawoke powerfully within the cramped spaces of the little wooden shack where he lived and worked. Here, nothing was ever thrown away. Paintings, photographs, phonograph records, and heirlooms shared the space with old crockery, shopping lists, stacks of correspondence, and every conceivable "banal" object. Over the years, this jungle of things became more and more lush, and he and his sister barely had room to unfold their camp beds each night. For Sudek, it also became a laboratory of artistic sorcery, of objects configured by his imagination and by his camera.

Some still lifes were composed as homages to his friends; others were conceived in terms of admired painters, a twist on his practice of photographing his favorite paintings. There are photographs made after Caravaggio and Navrátil, and several echo Chardin and seventeenth-century Dutch painting. For his constant experiments in the genre, Sudek kept a stepladder overflowing with still life arrangements: a plate with an egg; a lemon on a piece of tin foil, a goblet half obscured by a wine glass. Intrigued, his artist friends soon began sketching arrangements placed on the window sill.

Although Sudek had retreated, he had not become a hermit. He still carried his camera into the streets, and up to the castle and the cathedral. It was in the castle gardens that he met a kindred spirit, the architect Otto Rothmayer, who would in the postwar years be party to some of Sudek's eeriest work, and also to one of his few public misadventures.

The war was coming to an end. The Czechs took to the barricades against their Nazi oppressors four days before the Red Army reached the city. Sudek had survived, he had grown as an artist—and yet there was one particularly painful loss. Jaromír Funke had been his closest friend, beginning with their photographing and drinking days during Sudek's convalescence after World War I. It was a friendship that grew as they battled the old school and forged new territory in photography. And in 1945, Funke died; he was not yet fifty-one, and was still primarily viewed as an intellectual photographer. Among future generations, some would judge Funke as never having reached his full potential as an artist. He would ever after be known as "the experimenter"; Sudek, who would live another three decades, would come to be called "the harmonizer."

There were new friends though. "After the war, unexpectedly, a new face showed up at Sudek's studio," wrote Vladimír Fuka, Sudek's assistant during the war years. "A Jewish girl. A scarf tied around the pretty, still almost childlike face. She had lost her hair in German concentration camps. She had no one, nobody had returned." But she knew she wanted to be a photographer. Sonja Bullaty became Sudek's assistant, apprentice, and friend; she would eventually be a critical influence in bringing his work to a wider audience in the West.

In her own beautiful monograph on Sudek, Bullaty wrote that she did not recall her first meeting with her mentor. She asked him about it later, and he said; "You were much too preoccupied with what you had gone through to bother much

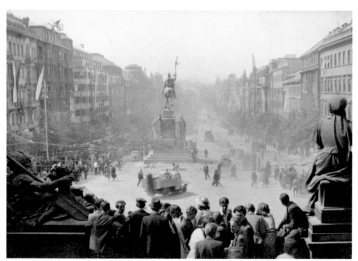

Josef Sudek, Wenceslaus Square, 1945.

about any of us or to take in your surroundings." Bullaty continued, "Perhaps there was an immediate understanding between us and neither spoke of what was too painful. It was good to face each day at a time, to just be. . . ."

Bullaty witnessed the frenetic pace Sudek maintained while climbing the hills of Prague, photographing with old cameras on heavy tripods. "Somehow the fact that he had only one arm never seemed a handicap." After she emigrated to the United States, their ties, as well as Sudek's ties with other emigré friends continued. In many ways they grew even closer through exchanges of letters, photographs, and phonograph records. In the 1960s, Sudek would incorporate some of the letters and objects he received into "Air Mail Memories." Several of his letters written to Bullaty in the early 1950s portray the always original, and sometimes baffling mix of characteristics that made up Josef Sudek's personality.

One of these ambivalent characteristics concerned his personal relations. Sudek was always known as a caring, generous man and a sympathetic listener. He also seemed to many to be aloof because he possessed a will to shield himself—and others—from painful emotional shocks. And with losses of loved ones and friends, the emotional shield strengthened. After a death, he might not even mention the name of the deceased for a year. Or, as in the often laconic way he referred to the loss of his arm, the tone might seem almost too impersonal and matter-of-fact. One letter to Bullaty, for example, included the following, rendered to reflect Sudek's whimsical orthographic idiosyncrasies:

. . . then Mother decided to dye on us (she was 84 yrs of h). She had too reasons: first, her own father dyed at 84 him self, and second, she felt it wasn't worth her while to go on living. And as she wished it very much, she managed to dye with in too weaks and didn't have to spend much time lying and waiting. Then my friend [Emil] Frinta dyed as well which brings us to the end of 1953.

In that same letter, Sudek was agitated by the drastic devaluation of currency that cost Czech citizens virtually their entire savings:

My finansial circumstances have been some what better lately, butt it was really bad after the big bankruptcy. Luckily enough some friends got me a few commissions, other wise I would of had a terrible time. It was a big crash all right: to liquidate all private and state property and all capitol with it in a mere 5 yrs, devaluating the currency at 1:50 takes some doing. The only advantage is it affected everybody including the workers and I hope it helped everybody sober up. Naturally, the rallies in factories and the newspaper leaders hailed it loudly. . . . I was worse off than when I had started 26 yrs ago. Butt what the hell, we shall see. My sister and I live quite modestly butt still have trouble scrounging enough for food and my photography.

Despite the difficulties, Sudek was full of plans for photographic projects. He wrote to Bullaty:

Last yr we had Janáček's anniversary and friends kept telling me to submit my photography of Janáček's Hukvaldy where I spent three summers taking pitchers. I didn't want to, knowing it would be senseless with the situation being what it is, butt they kept insisting I should at least try and so I gave in butt the publishing house returned my work saying it was too exclusive. I am sure if I coughed up portraits of some steel workers, it would be a different story all together butt thank God I'm too stupid to do that. So you can sea things ain't what they may seem. Talking shop, I'd like to do more of those sausage-long views of Prague.

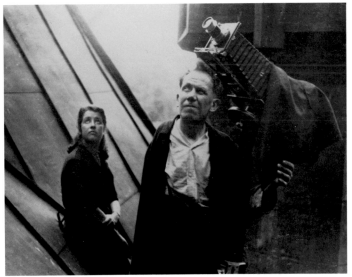

Sonja Bullaty and Josef Sudek, 1945-46.

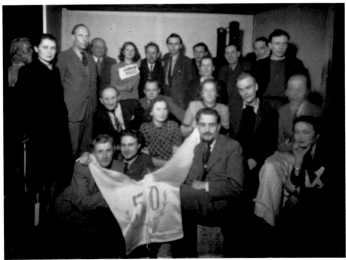

Josef Sudek's 50th birthday party, 1946. Sudek, top row, fifth from the left.

Sudek's fascination with the panoramic image dated back to his early youth, when he had first created a wide-angle landscape by pasting two prints together. He also remembered an American-made panoramic camera he had seen in a catalogue

during those years, and immediately after World War II began his search for what was now an antique. Sudek was then visiting and photographing Frenštát in the Beskyd Mountains, and was obsessed by the possibilities of the panoramic landscape. Finally, he chanced upon the camera, old and neglected, sitting on a shelf in the home of an acquaintance. Sudek received the camera as a gift, and then used all of his legendary patience to make it workable.

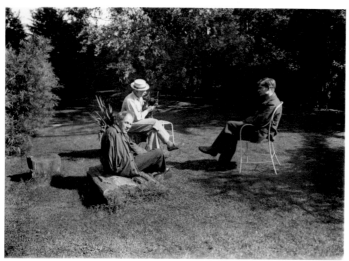

Rothmayer's Garden.

After months spent finding a replacement for the moth-eaten leather on the camera, Sudek then discovered there were no film rolls to fit the format. Kodak, which had made the camera in 1894, had long abandoned its film. Using German stock, Sudek created his own film by cutting and splicing. A shipyard welder devised a metal plate that had to be knocked into place to hold the film, and could only be unloaded by knocking it free—which meant Sudek had to return to his studio to unload. Rothmayer then suggested Sudek have a large bag made for unloading. Sudek gradually brought the archaic instrument under control, coordinating his one good hand and arm, and his teeth. It was an extraordinary feat, but given his descriptions of those early attempts, it was clear that this challenge was only the beginning:

Using this box camera completely changed the space. The perspective was different . . . what had been intended as a dominant suddenly wasn't the most important thing at all . . . I found out I had to look as if I were the camera.

Sudek's technique for learning to see as if he was the camera found him peering through his left hand which he held like a kind of funnel over his eye. The gesture was as original as it was unsettling—to at least one passerby:

Let's say I was walking along and suddenly I turned back. One day

this thing happened to me. I walked up Neruda Street, stopped and quickly turned back twice. There was this old lady passing by and she became frightened, thinking I was off my rocker.

Reorienting his vision—manipulating sight and mind to emulate a camera manufactured two years before he was born—yielded yet another transformation in Sudek's work. Rendering his panoramic images in both horizontal and vertical formats, he revisited the streets of Prague, travelled to forest preserves, and began a fresh study of trees. In a few instances, Sudek even used it in the narrow confines of Rothmayer's garden, where he embarked on one of his most original series. Asked to photograph chairs Rothmayer had designed for his garden, Sudek immediately accepted—admittedly with the ulterior motive of gaining access to the garden itself. "A Walk in the Magic Garden" remains one of Sudek's strangest, most perfectly fulfilled poetic cycles. Rothmayer was an actual collaborator, helping set the stage for many images in the series. Sudek was in complete sympathy with the architect's feeling for old tree trunks, unusual garden lights made from rusty concrete reinforcing rods and bits of found glass, and the almost Japanese composition of rocks, branches and greenery. And glass eyes and other disturbing incursions—bits of magic—were also brought into the garden.

Sudek's photographs have often revealed a bizarre imagination. As early as the war years, he had started a series first with veiled women, and then a cycle of portraits in which the women's faces were entirely wrapped so that the features were barely readable. With Rothmayer, he extended this idea and among other works made *Lovers,* two relief masks, one white, the other black, posed gazing glassy-eyed at each other on the architect's desk, and photographed under varying lighting conditions.

As Sudek approached sixty, it seemed that time was still his ally. From 1940 through the 1950s, he initiated the greater part of his artistic masterworks, following his own philosophy of "hurry slowly." Aside from "A Walk in the Magic Garden," on which Sudek worked during the fifties until Rothmayer died in 1966, and many book projects, he continued with the windows series, portraits of friends, Prague parks and gardens, as well as the simple still lifes—which from 1950–56, he did in pigment. During this period, he also began an extraordinary cycle on the Mionší Forest Preserve, located a few hours from Frenštát. Sudek's friend Dr. Petr Helbich had taken him there, thinking, correctly, that he would be inspired. The preserve was entirely untouched, an almost autonomous landscape in a ghost-town-like atmosphere. Sudek had an affinity for solitary, old, damaged trees, and in the Mionší Forest, he discovered something primitive and wild, even brutal—unlike the groomed parks and gardens of Prague and the gentler quality of the city's surrounding countryside. Helbich recalls journeying with him through Mionší:

We climbed to the top, always taking the same path. . . . As usual, Sudek walked with his head down. Suddenly he stopped. Perhaps he had just glimpsed the right light by his feet. Shaping his left hand into a funnel, he looked about and ordered: "Hey, Assy! [Sudek's nickname for his assistant] Here! Set 'er up!"

The poet Jaroslav Seifert also accompanied Sudek on some of his expeditions, and offered a similar description of the photographer at work, probably on the slopes of Petřín Hill:

He was coming. His camera was already attached to the tripod, and he was carrying both, along with a heavy bag on a strap, over his left shoulder. In the shoulder bag he had several additional lenses and other equipment. For a single arm, it was quite a load. . . . Sudek positioned the tripod in the sand of the path, looked around him for a while, and then carried it to at least three different places. All that with his left hand. The empty sleeve was dangling from the right side of his coat. When he was getting the camera ready, he helped himself with his teeth. At the moment, he was holding in his mouth a piece of a soiled black cloth, and with his tousled lock of hair looked like a lion dragging a piece of meat. I wanted to help him. All right then, I was to hand him the first plate. He rounded his palm and fingers to form a telescope of sorts in front of his eye. . . . He waited for a long time for the right light. Maybe half an hour, maybe an hour. When it did not materialize, he picked up the camera and we moved to a higher place. And we waited again. He wrestled with the light like Jacob wrestled with the angel. . . . He did not speak. . . . Only from time to time he whispered to himself his favorite saying, "the music keeps playing". . . . The entire ceremony was very slow, but severe and exact.

After 1948, Sudek's intuitive, imaginative, individualistic photographic vision was incompatible with the collectivist fervor of the Czechoslovak Socialist Republic. As he had predicted, his early submissions to publications were rejected. And yet, it was the most prestigious socialist publishing house that issued the first monograph devoted to the photographer's work, *Josef Sudek - Fotografie*, with an introduction by Lubomír Linhart, poetry by Vladimír Holan and Jaroslav Seifert, and graphic design by František Tichý.

It was not easy to publish a book of this kind in the mid 1950s. Art as a reflection of reality—in this case, a prescribed reality—was the primary tenet of Socialist Realism, and Sudek's work did not in any way fit that directive. In his essay, Linhart praised Sudek, and at the same time apologized for the photographer's "formalism . . . erring ways and disputable tenets . . . apologetics of Cubism . . . obsolete principles of photogram . . . photography gone astray . . . erroneous return to vision foreign to today's perspectives . . . evasion of life. . . ." Nobody will ever know what Linhart's real intentions were, whether he really believed this party-line position of a Marxist-Leninist dialectician,

or whether he simply wanted to ensure the book's publication. Whatever the truth, Sudek could not have cared less about its ideological implications: "After all, it is the author who signed underneath the article; the photography is mine, and only time will tell."

As it turned out, Jan Řezáč, the editor-in-chief of State Belles Lettres Music and Art Publishers, which issued the mono-

Josef Sudek, Veiled Woman.

graph, was an enlightened and tireless supporter of the photographer. In the four years following release of the monograph, Řezáč published three more Sudek books, including the magnificent *Prague Panoramas*.

Prague Panoramas is one of the landmarks of world photography. Sudek had achieved absolute mastery of his old and patched-up camera. With it he had revisited the city he knew in all of its majestic and intimate perspectives, all of its arcane and homely detail. *Prague Panoramas* offered a new, symphonic vision, one that had been neither seen by the eye nor conveyed by the camera. The book had also involved three of Sudek's

closest friends as collaborators: Řezáč, Seifert, and Rothmayer as designer. It was in every sense a work of love.

Sudek's books were issuing forth and official honors began to accrue as well. The Deputy Mayor of Prague announced that Sudek had won the annual Municipal Prize, to be awarded in April 1955. Sudek declined, explaining only that he could not participate in any meeting, and sent in a photograph of Prague, "in lieu of myself." The next year, the Czechoslovak Union of Artists nominated him to the art photography commission. Two years later, the Union pronounced that Sudek was "an outstanding art photographer and as such enjoys our society's full support and protection of his rights." Almost simultaneously, Sudek was named to the editorial board of State Belles Lettres Art Photography Edition. And so in one of those paradoxes that mark Sudek's career, this least ideological of photographers became a powerful voice in shaping photographic standards in the Socialist Republic.

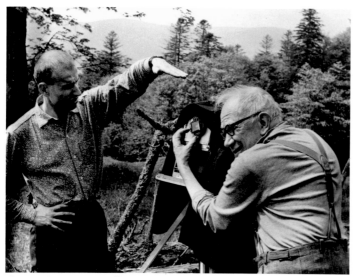

Photographing in the Mionší Forest Preserve, 1970.

At home, however, circumstances were forcing a great personal ordeal. The ever-accumulating objects were driving him out of the now dilapidated shack where he had lived and worked for thirty years. The situation had been difficult but manageable because his sister had spent several days each week caring for their mother in Kolín. After Johanna's death, the difficult became the impossible. Božena brought to Újezd as much of her mother's furniture and other possessions as could possibly be made to fit, storing the considerable remainder with a loudly complaining landlord in Kolín. And then there was Sudek's relentless accumulating. Besides housing his photographic materials, negatives and prints, the studio became a pulsing repository of those inanimate objects that Sudek endowed with life. And it hummed with echoes of the dead: Božena kept a curious necrology, recorded on odd scraps of paper stuffed here and there. Sudek had to move.

Throughout his life, Sudek was a feisty, persevering haggler with authority. He had plagued bureaucracies during the Hapsburg rule for exemption from combat duty, fought for financial aid and tax relief in the Czechoslovak Republic. Now, he marshalled friends, institutions, and his own considerable energies to wrest a decent space in which to live and work from authorities who were trying to deal with an acute shortage of housing. Enlisted in the cause, the Artists' Union attested to the fact that his studio was about to collapse, the roof leaked, neighbors raided the garden, and the concierge had even appropriated Sudek's cellar. Sudek's own applications, documents, and correspondence piled up—including a compelling appeal to the Academy of Sciences observing that his negatives and photographs would one day constitute an invaluable resource for art historians. Although Sudek never obtained a real apartment through the authorities, he eventually found a former jeweler's shop at 24 Úvoz which would be his home and workplace the rest of his life. At Újezd, Božena cooked and laundered for her brother, attended to a myriad of chores in support of his photography, and unfolded her camp bed each night to sleep in solitude amidst the mountains of things. Sudek, although no longer living with her at Újezd, continued using the studio as a laboratory and darkroom, and Božena remained there alone until 1985 when a fire forced her to move out.

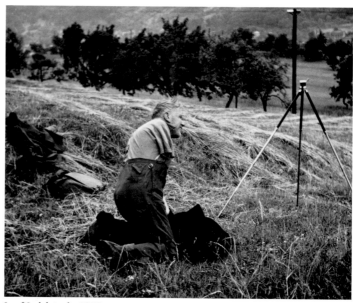

Josef Sudek in the 1950s.

Sudek's new quarters were exceedingly simple, modest, and functional—two rooms with vaulted baroque ceilings, adapted to include a miniscule bathroom with a shower. The larger room contained a gas range, some shelving, a safe left over from the jewelers shop, a huge round table with strong curved legs, and tin tubs originally intended for a darkroom. The tubs, however, remained in the room, never reaching their

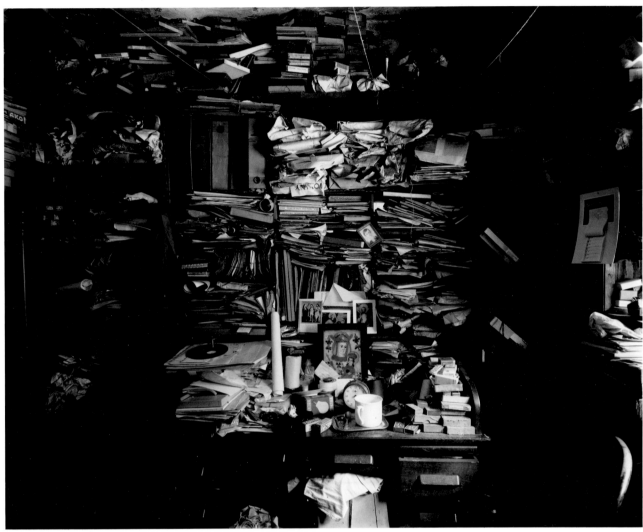

Josef Sudek, My Studio.

destination. Once again, things began to rule, usurping the table, overflowing the tubs, jamming the shelves. Perhaps it was a family curse, perhaps it was Sudek's need to create a world with an independent life of its own—unlike anything known from painting or photography—that nourished his imagination. Gifts from friends, things forgotten by visitors, bundles of papers, glass, small sculptures, regular souvenirs, and more—were all heaped side by side, and orchestrated later into the "Labyrinths" series, 1948–73.

In 1961, at the age of sixty-five, Sudek was awarded the honorary title of Artist of Merit. He was the first photographer ever to receive such a high honor from the Czechoslovak Socialist Republic. Through his books, calendars, commercial photography, and other work, he had acquired a following drawn from all walks of life. To his fellow Praguers, Sudek was a down-to-earth, dauntless character, always ready with an adage, a joke, or one of his famous curses. He was one of them until his exhibition opened at the Czechoslovak Union of Writers Bookshop in January, 1963 and his public was dismayed by what it saw.

That the exhibition took place at all was out of the ordinary: previously the space had only been used for paintings and graphic arts. Everything, it seemed, appalled the viewers. First, there was the design of the exhibition and the presentation of the prints—a collective effort by Sudek, Rothmayer, J. Tintěra who was an expert on paints, and R. Biskup, a glazier who created lead framing strips. The photographs were presented in ancient frames, with backing of unusual structure, fabric, or tinfoil; also, images were placed between two sheets of glass, bound together with lead strips, and backed by gold foil, bookbinder's endpaper, handmade paper, and other unusual matting. The effect was artificial, even decadent, and sophisticated in the extreme. The groups involved 112 images arranged in eight themes: "Views from the Windows of My Studio"; "A Walk in the Magic Garden"; "Garden of the Lady Sculptor"; "My Garden"; "Prague"; "Still Lifes"; "Memories of Arbes, Poe, Stevenson, Wells, and Wilde"; and "Notes."

The images included some of Sudek's most subjective, deeply personal explorations—not the fashion at the time. The

final insult, perhaps, was Sudek's printing. Most of Sudek's public—even his fellow photographers—knew his work from press, periodicals, or books. With his exquisite mastery of technique, he differentiated greatly between prints for display and those destined for publication. In the exhibition prints, dark greys almost fused with borders so that tonal values were all but imperceptible. It was precisely that infinitesimal control over tonal gradations that had drawn Sudek to contact prints, and precisely this quality that irritated the public who felt betrayed. The exhibition register shuddered with rejection: "too skeptical . . . can't make head or tail of his still lifes or what they're supposed to mean . . . very fetishistic . . . we want to see something dynamic and dynamism is what is missing here. . . . My feeling? Sadness, gloom, dejection, depression . . . whoever knows Sudek is in for some very big surprises . . . especially at these times, one would expect much more from an artist of Sudek's reputation . . . the framing is horrible. . . . Keep up the work, Mr. Sudek, but do try to see contemporary life." There was much more. Only Sudek's closest friends were enthusiastic, and only they knew that he had never marched in step with the times. The 1963 exhibition, however, was the first time the courageous photographer had publicly stepped to the music he heard.

Sudek was shaken by the experience. While he might battle or avoid authority, and refuse to cowtow to wealthy patrons, the rejection by his public and fellow photographers hurt. He was a popular informal speaker at amateur photography clubs, but when members of his audiences saw the exhibition prints which they had previously known only through reproduction, the enthusiasm faded. Some clubs even refused to exhibit his work because of its "poor technical quality." Although saddened by the lack of understanding, Sudek's response was true to form. He launched into the most uncompromising and unearthly series of his career: "Labyrinths," his crowning achievement.

Labyrinth . . . 1. A structure consisting of a number of intercommunicating passages arranged in bewildering complexity, through which it is difficult or impossible to make one's way without guidance. (Oxford English Dictionary)

Where does one find the entrance to Josef Sudek's labyrinths? There is no precise entry point in time, for the maze twists and turns through his life and threads back into his childhood. Nor is there an exact place, not even Prague, because the imagery has no counterpoint in reality. The labyrinths—like the true archetype Daedalus wrought—are of mind and spirit. Even with Sudek as guide the follower must rely upon a deep understanding of music and art, a chorus of muses, to find the way. One might as well begin with pigeon feathers.

"Air Mail Memories," a series that extended from 1960 to 1973, was a tribute to friendship. One intimate cycle included pigeon feathers sent to Sudek by Bullaty in the course of her travels. Exotic stamps and postmarks from the envelopes of letters sent by friends from abroad and the unusual typography and design of foreign record album covers intertwined with a growing forest of items and light-sensitive papers atop the huge

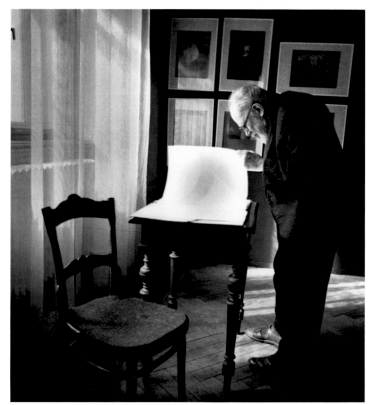

Josef Sudek at his retrospective exhibition, a few months before his death in 1976.

round table. The maze changed constantly as minute objects were shifted here and there in a tangle of magazines, catalogues, strings, and religious objects. From this animate tabletop emerged other cycles—"Memory of Hofman", "Easter Reminiscences"—and the series wove through memories of lost friends and childhood, following the passages of a grand design.

In connection with his own work, Sudek first used the term "labyrinths" in 1968. Perhaps it was an inspiration or, just as possibly, he cheerfully appropriated it from an artist friend, Vladimír Fuka, who used it in his own work as early as 1964. As Sudek was fond of saying, everyone has to "pick his plums somewhere." In his sweeping overview, Sudek's "Labyrinths" extended from 1948 through 1973, virtually until the end of his photographic career. Within these were various other groupings, such as "Paper Labyrinths" and "Glass Labyrinths" from 1968 to 1972. "Labyrinths" is a monumental autobiography of memories, dreams, relationships, moments of beauty heard and seen: a narrative of intimate, shimmering symbols scaled to a mythic universe.

By the mid sixties, fashionable trends that had dislodged the public's loyalties were spent. In 1964, Prague's Artia Publishers issued an international edition of a monograph of ninety-six of Sudek's most poetic images from the "Windows," "Gardens," "Still Lifes," and "Prague Parks" cycles. Translated into French, German, and English, Jan Řezáč's introductory essay described Sudek as:

One of the artists to humanize the inanimate objects of his nonconforming environment and thus to overcome man's alienation. . . . Society's problems and struggles, without which modern sensibility would be sterile, are transformed by him into wonder and admiration for life's simple things, whose elusive beauty is almost impossible to capture. Josef Sudek transports us to the long-lost magic of childhood, love, and poetry. Sudek's photographs are a certain dark uncertainty.

Řezáč also unabashedly called Sudek "one of the greatest photographers of all time." That claim slowly, inexorably gained support, first in the United States and subsequently in Europe.

In June 1967, Sudek was invited to participate in the exhibition *Five Photographers,* organized by the University of Nebraska, along with Eikoh Hosoe, Bill Brandt, Ray K. Metzker, and John Wood. Bullaty helped with this show, and also with the publication of his photographs in *Infinity* magazine. Other major magazines in the United States and Europe soon opened pages to Sudek's images, and he was called upon more and more to send prints for exhibition.

He also continued an active commercial business that included photographing the works of painters and sculptors as he had always done, as well as commissions for calendar photographs, and other projects. No other photographer in the country enjoyed his official status, and perhaps no other worked as hard, well into his seventies. And still, after a long day's shooting, he would attend a concert. There, in some favorite hidden spot, he entered into a trancelike state, waving his hand or even humming along with the music to the occasional annoyance of his less entranced neighbors. The next morning, he would be preparing for exhibitions, or out shooting again, working on a last gift for his countrymen, at home or in exile.

For twenty years, Sudek had been photographing in the great, untamed Mionší Forest Preserve. But it wasn't just the decaying trees, their sculptural quality and otherworldly resonance that drew him there, it was the haunting music he felt coursing through the landscape—especially the music of Leoš Janáček. Sudek had widened his photographic expeditions to include the countryside around Janáček's village, Hukvaldy, and ultimately, the composer's home. His greatest tribute to this composer was published as *Janáček-Hukvaldy,* in 1971. Discussing his introduction to Janáček's music, Sudek reminisced with Karel Soukup around his eightieth birthday in 1976:

With Janáček, I wasn't sure whether the orchestra was just tuning or playing for real at first, but I kept telling myself: "Listen, if it's considered so great, maybe it's you who is stupid. There must be something in it!" And so I went to see Jenufa *again and again. And then, the fifth time in a row, it was as if the curtain rose in the middle of the second act and the musical mess was gone. . . . Suddenly I began to hear all those melodic lines and I told myself: "Hell, so this is what's so great about it!" And I became quite obsessed with Janáček.*

Janáček-Hukvaldy, according to the musicologist Jaroslav Šeda, was not a book, "but a poem inspired by Sudek's love of Janáček and his engrossing, enrapturing music. When he first visited Hukvaldy and the pastorally balladic, tender, as well as rough and wild countryside, he immediately knew it was the visual image of Janáček's music."

Springtime was Sudek's favorite season, and as the trees burst into leaf and Prague came into flower, the music, by 1976,

Josef Sudek at his retrospective exhibition, a few months before his death in 1976.

was flowing into a graceful coda. The Tuesday evening salons had come to an end, and although friends still called, Sudek's strength was ebbing: drop by drop he was bleeding to death from a small internal tumor. Still he was full of plans for exhibitions and projects. And there was one final visit to the scene of his childhood. On September 4, after some hesitation, he decided to attend an exhibition of Jaromír Funke's photography in Kolín, where they had met and become close friends more than a half-century earlier. On a beautiful summer afternoon, he visited the graves of Funke and of his long-dead mother and

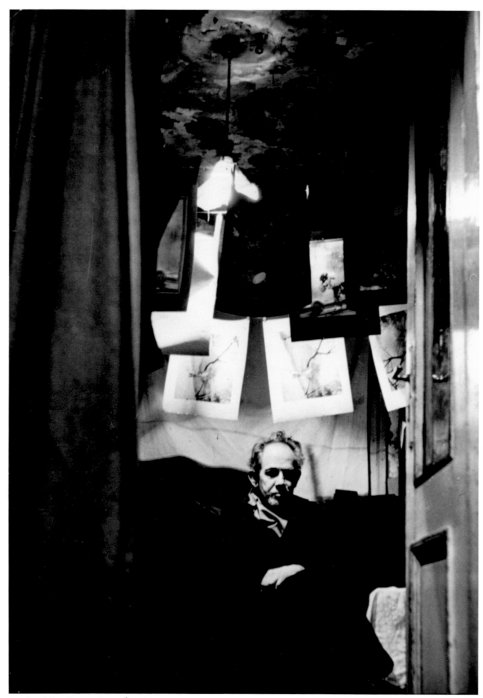

Josef Sudek in his Studio at Újezd, 1956.

father. In less than two weeks, Sudek was laid to rest beside them.

When Sudek's material was being catalogued, a photograph he had made of pages from a book, its author not given, was discovered—perhaps his final poem of love and light:

Yet, love, mere love, is beautiful indeed
and worthy of acceptance. Fire is bright,
let temple burn, or flax. An equal light
leaps in the flame from cedar-plank or weed.

And love is fire, and when I say at need
I love thee . . . mark! . . . I love thee! . . . in the sight
I stand transfigured, glorified aright,
with conscience of the new rays that proceed
out of my face toward thine. There's nothing low
in love, when love the lowest: meanest creatures
who love God, God accepts while loving so.
And what I feel, across the inferior features
of what I am, doth flash itself, and show
how that great work of Love enhances Nature's.

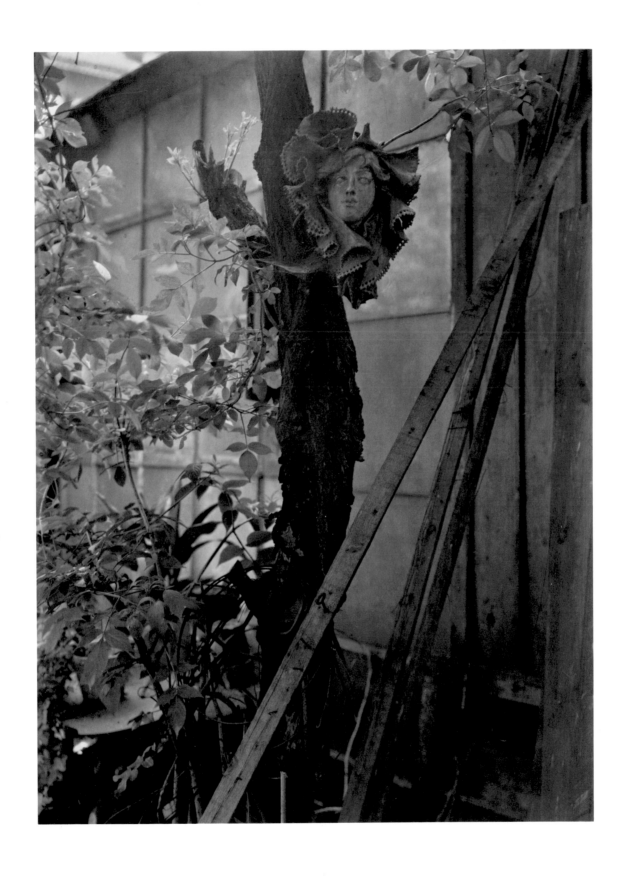

A Deepening Vision: The Later Photographs

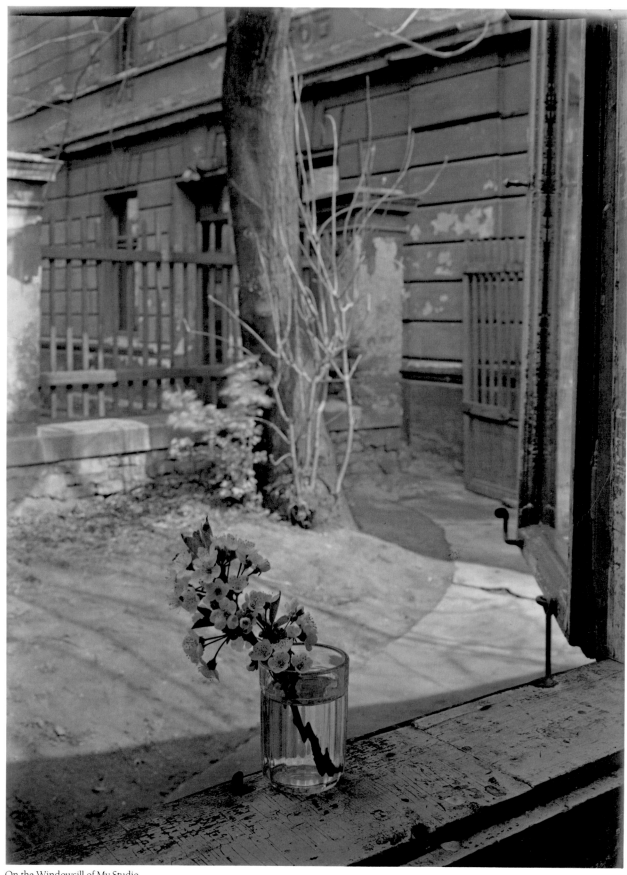

On the Windowsill of My Studio.

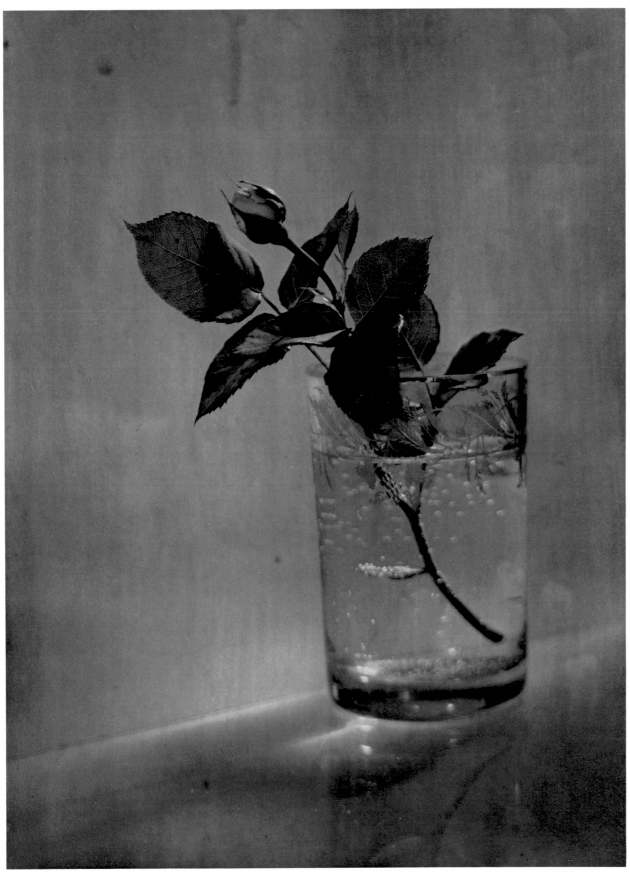

White Rosebud, 1954.

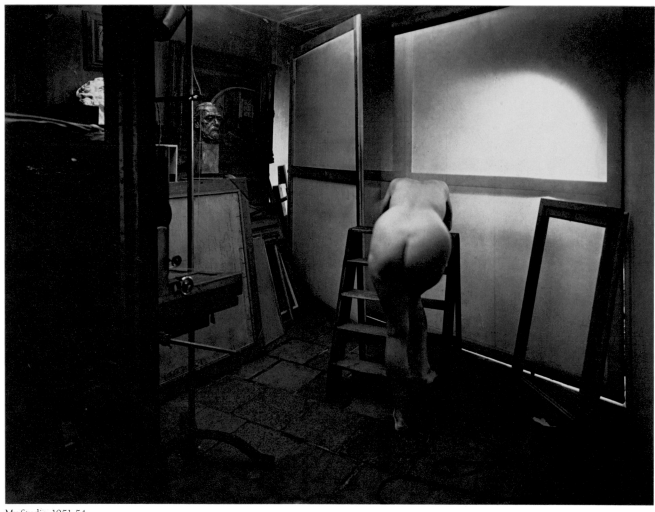

My Studio, 1951-54.

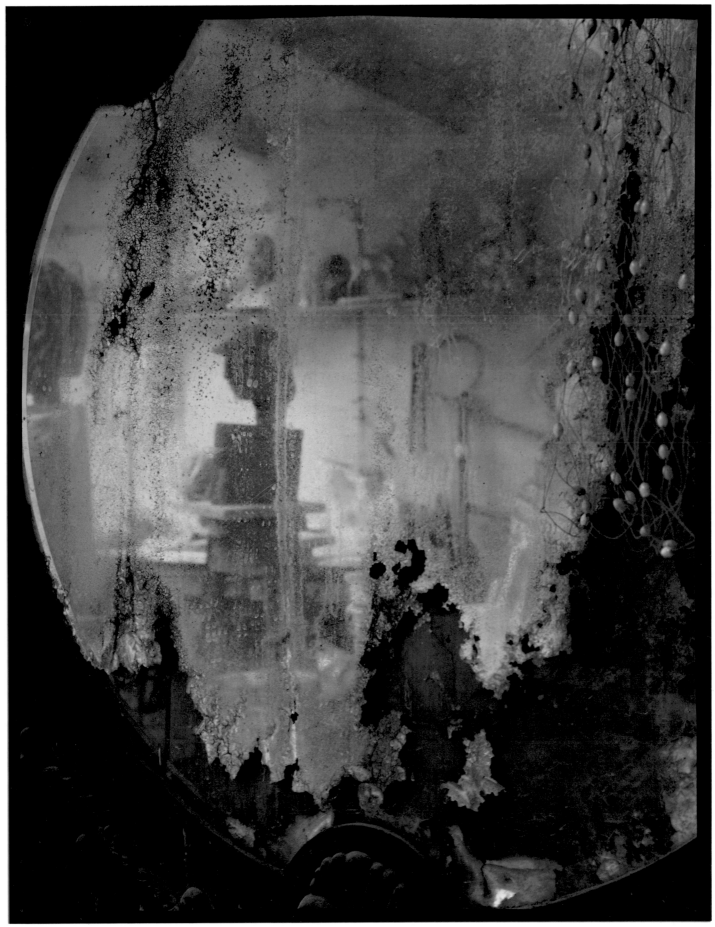

Reflection.

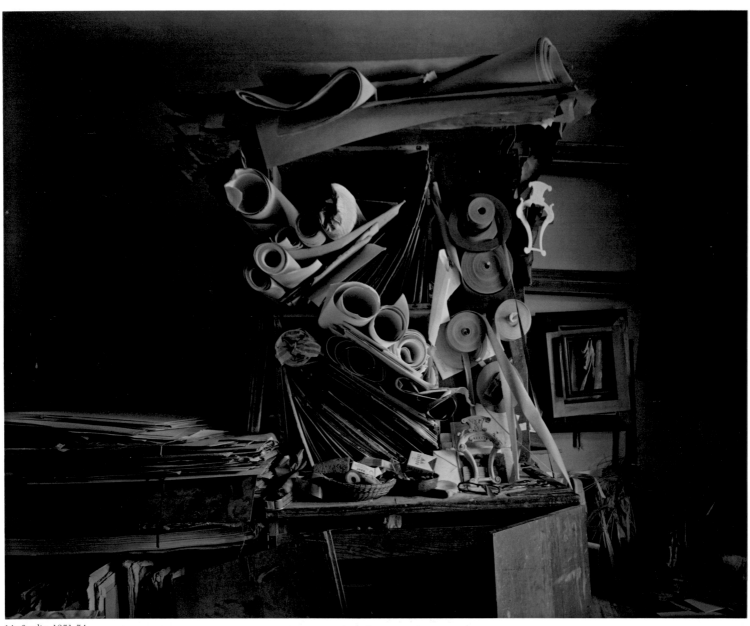

My Studio, 1951-54.

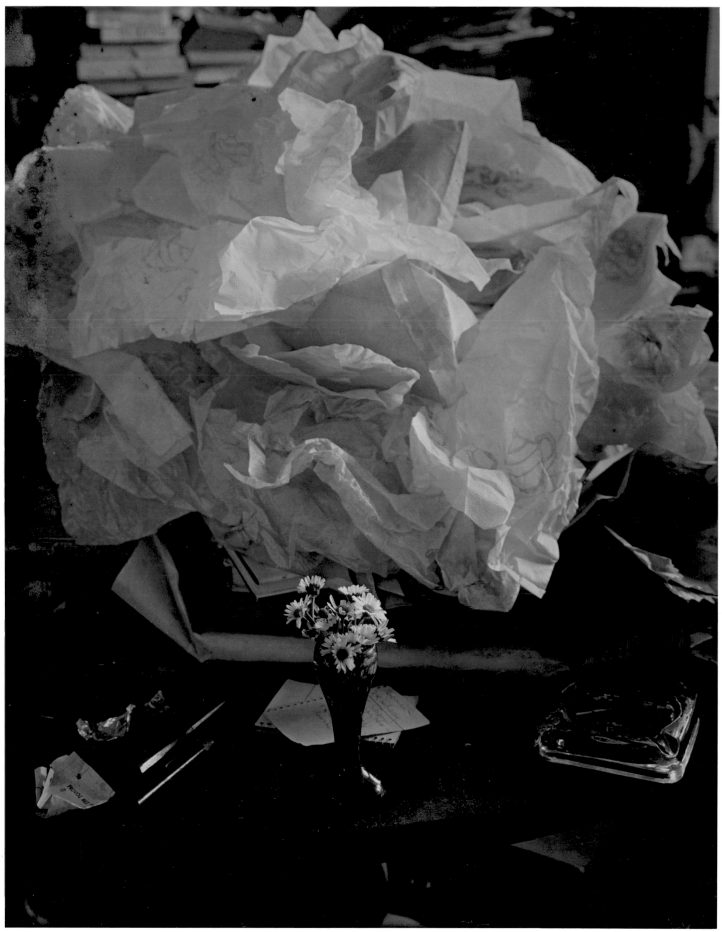

Memory of Hofman, 1975.

I have no particular leaning toward . . . the all-too-clearly defined; I prefer the living, the vital, and life is very different from geometry; simplified security has no place in life.

Memories, Lovers, IV Variations, 1948-64.

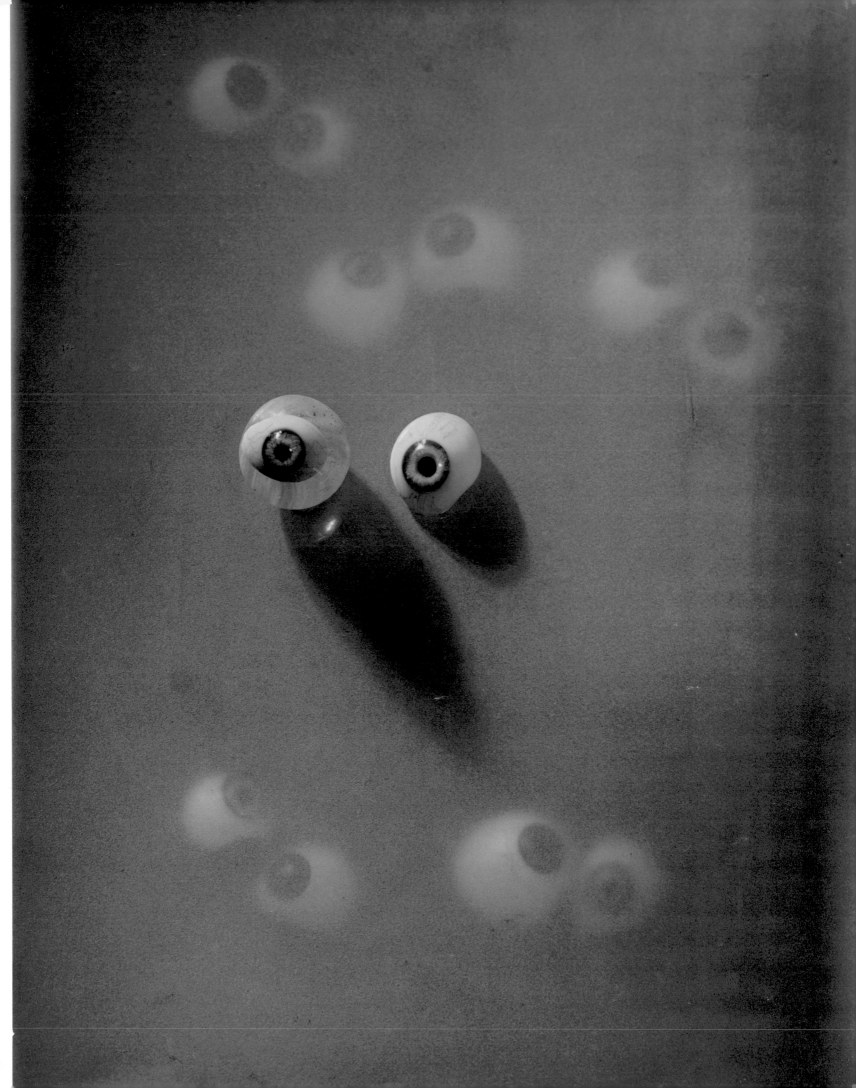

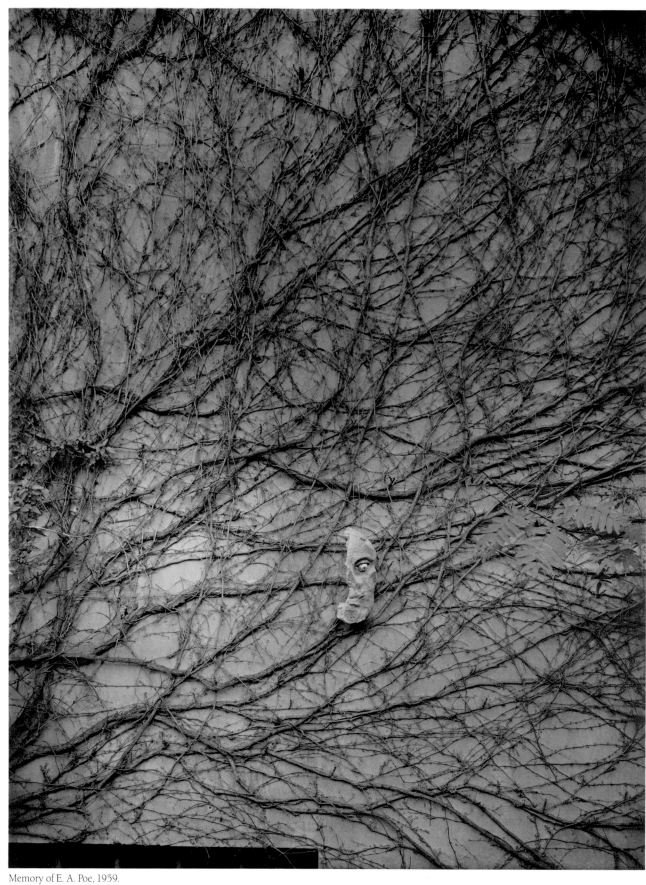

Memory of E. A. Poe, 1959.

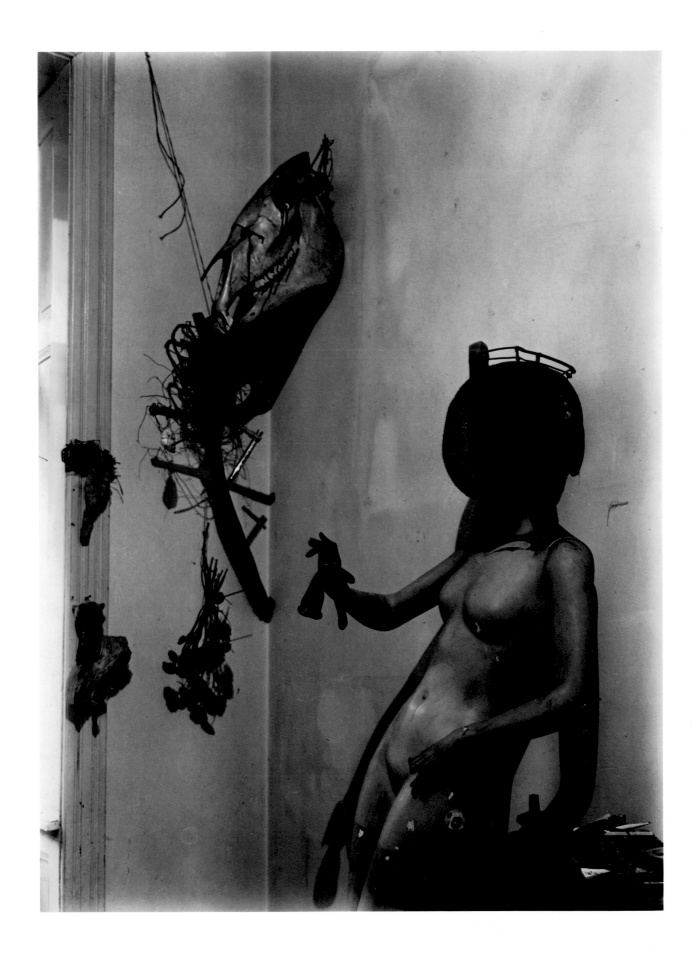

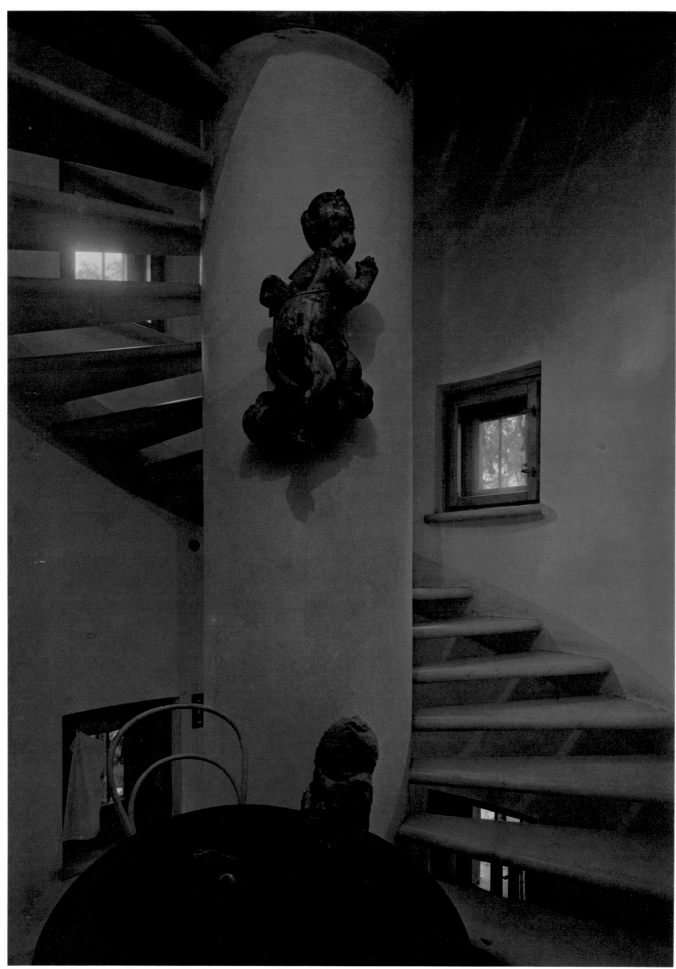

The Staircase of Rothmayer's House, ca. 1943. Opposite: My Garden, 1969-70.

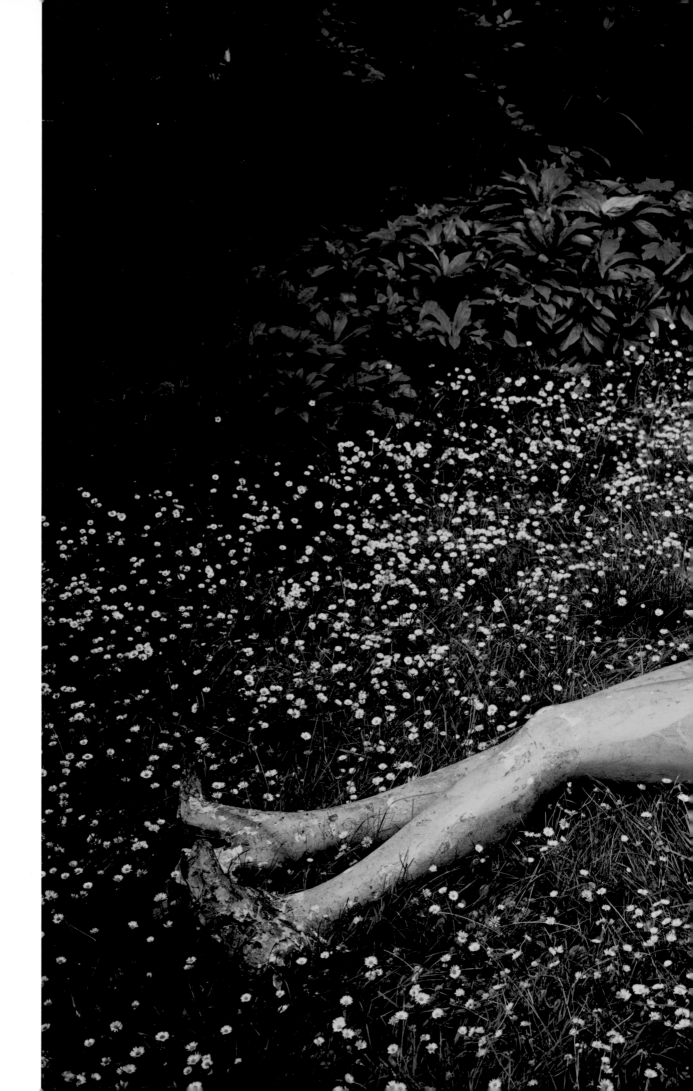

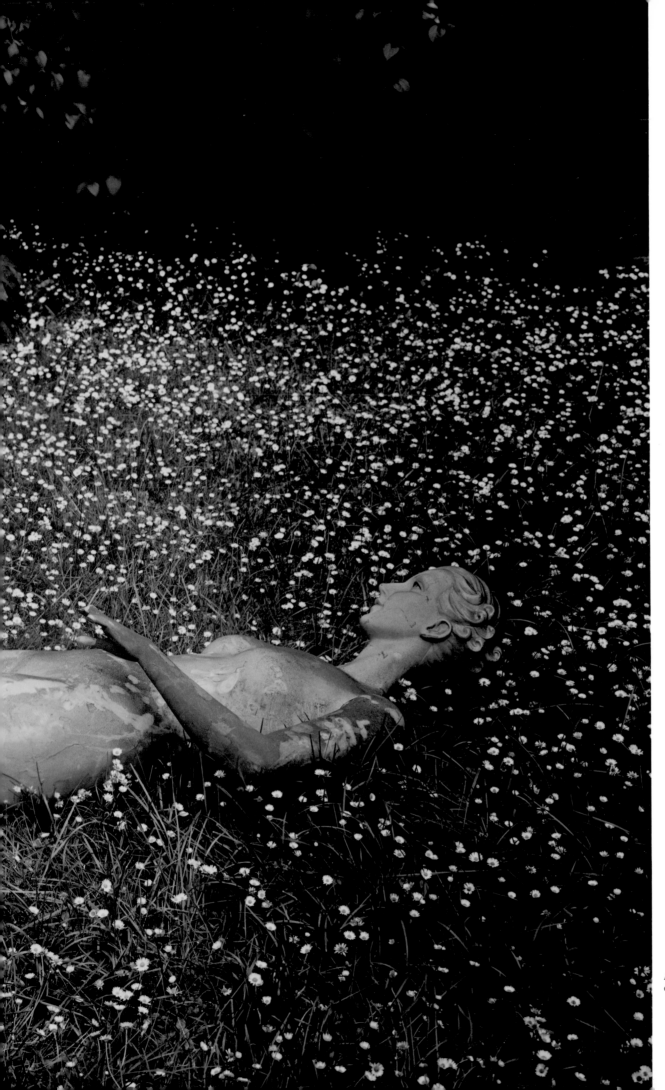

A Mannequin
on the Lawn.

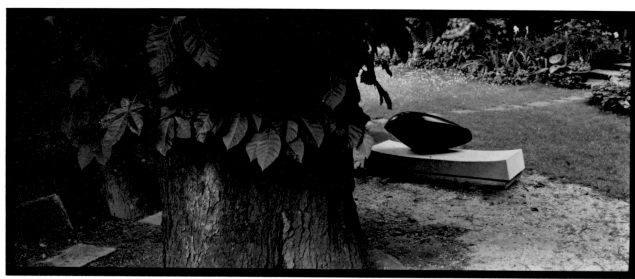

Notes from the Garden of the Lady Sculptor, 1957.

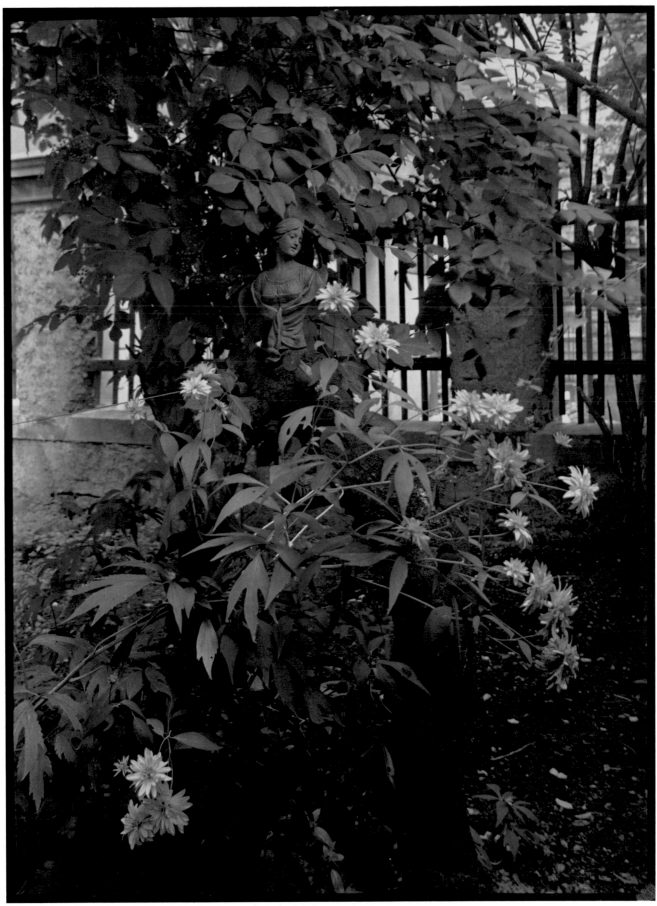

My Garden. Page 110: The Garden of the Lady Sculptor, 1953-57. Page 111: Malostranský Cemetery.

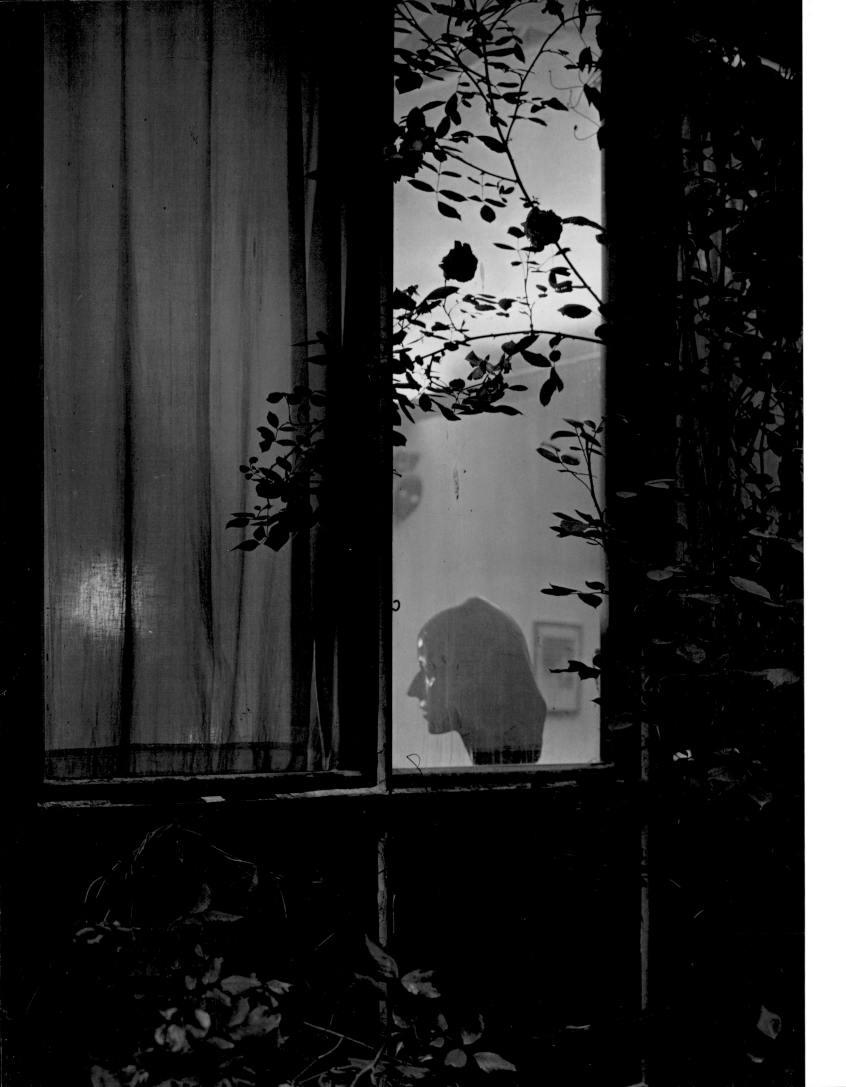

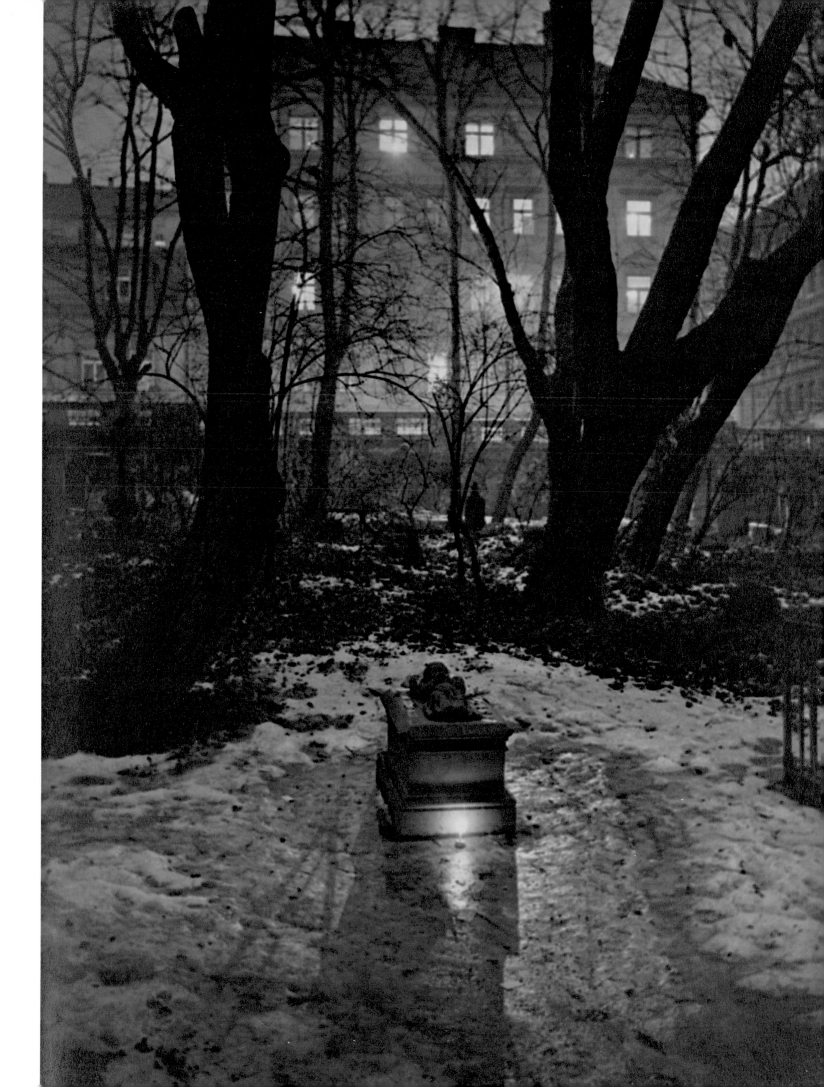

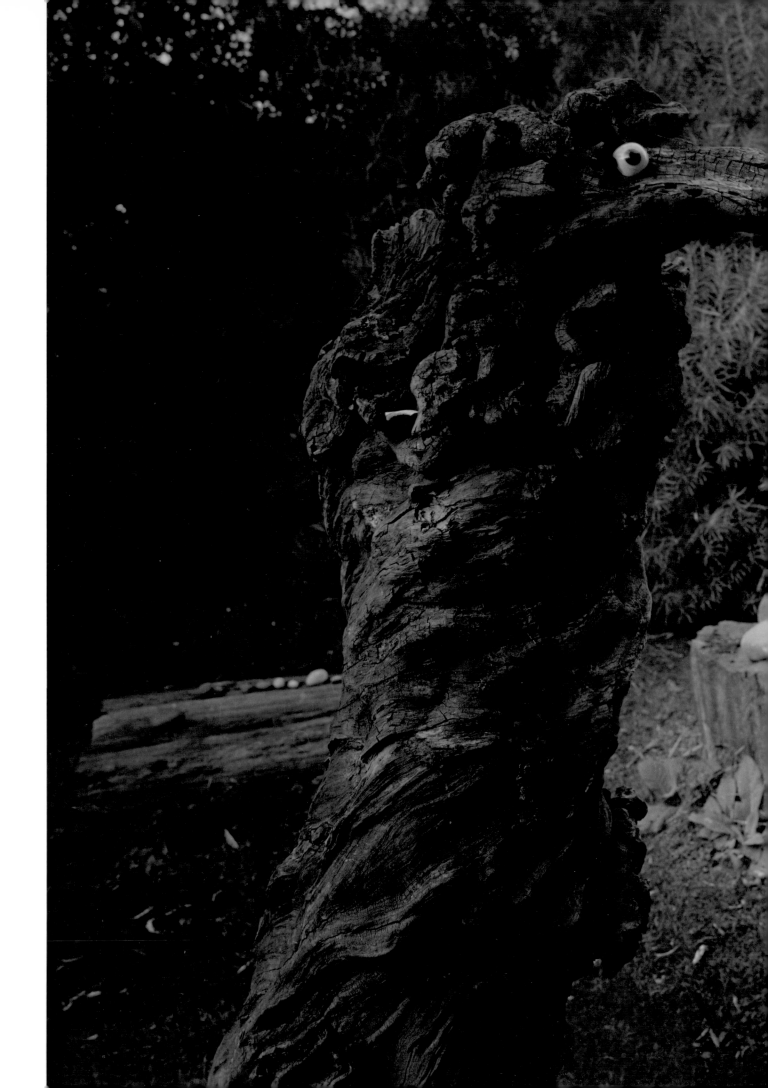

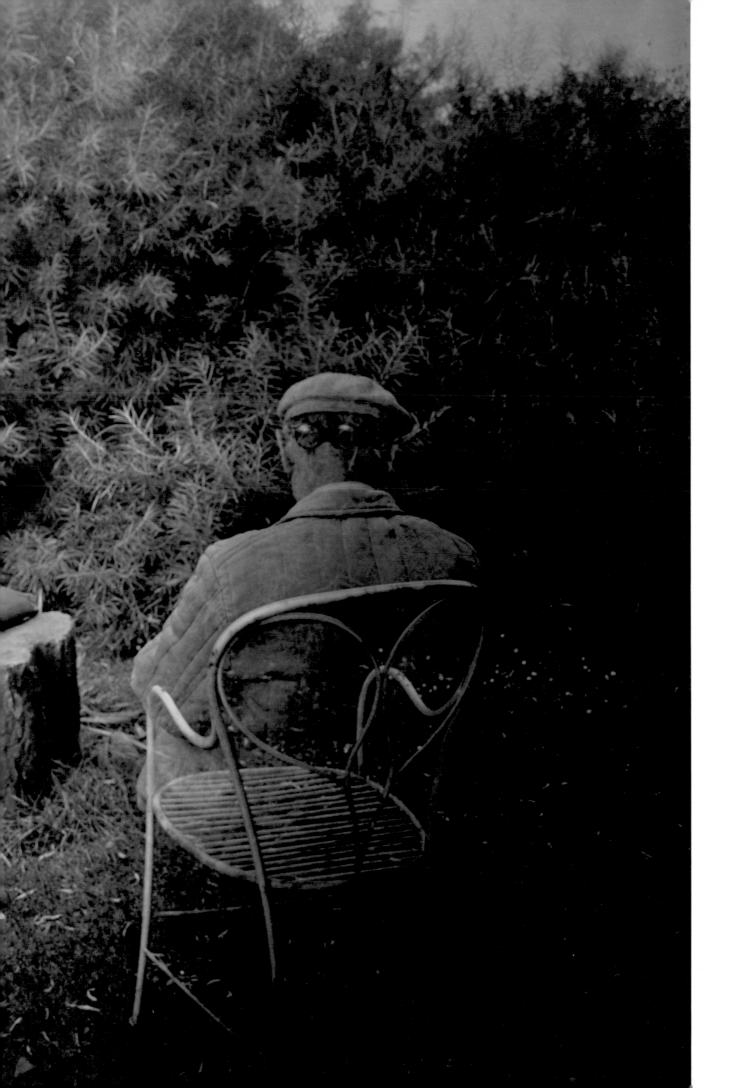

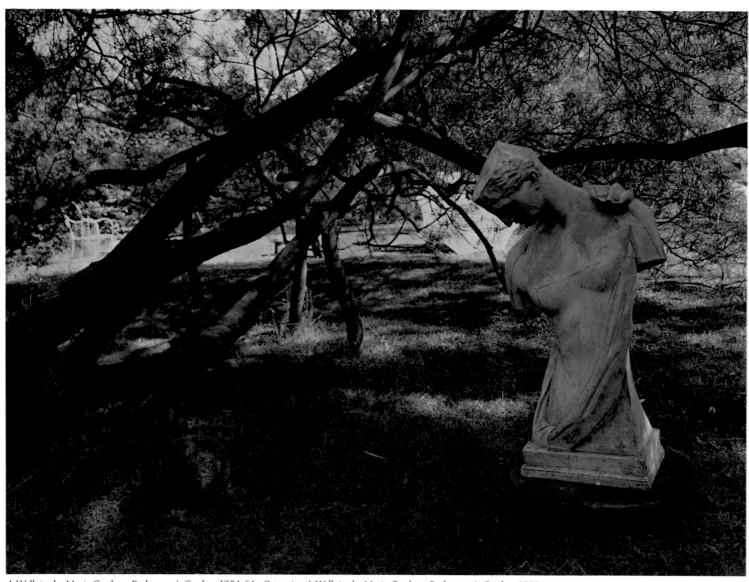

A Walk in the Magic Garden – Rothmayer's Garden, 1954-64. Opposite: A Walk in the Magic Garden – Rothmayer's Garden, 1955.
Page 112: A Walk in the Magic Garden – Rothmayer's Garden, 1959.

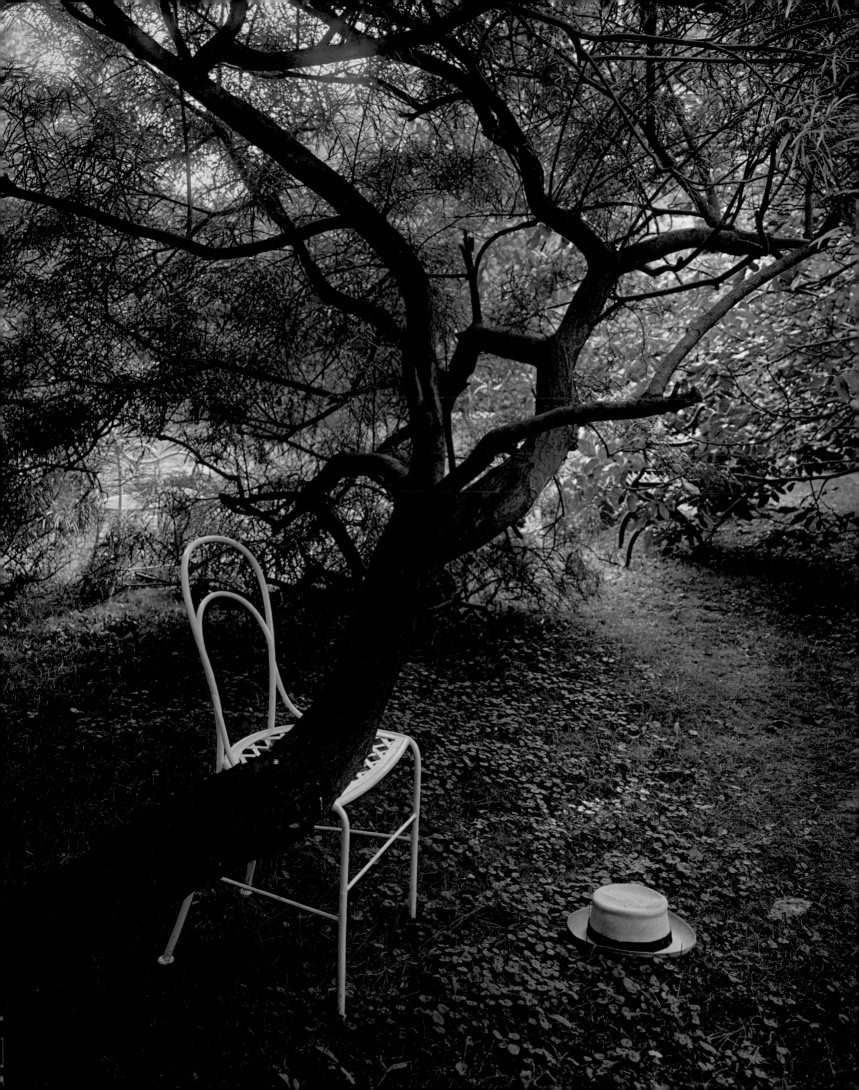

Lovers, 1960.

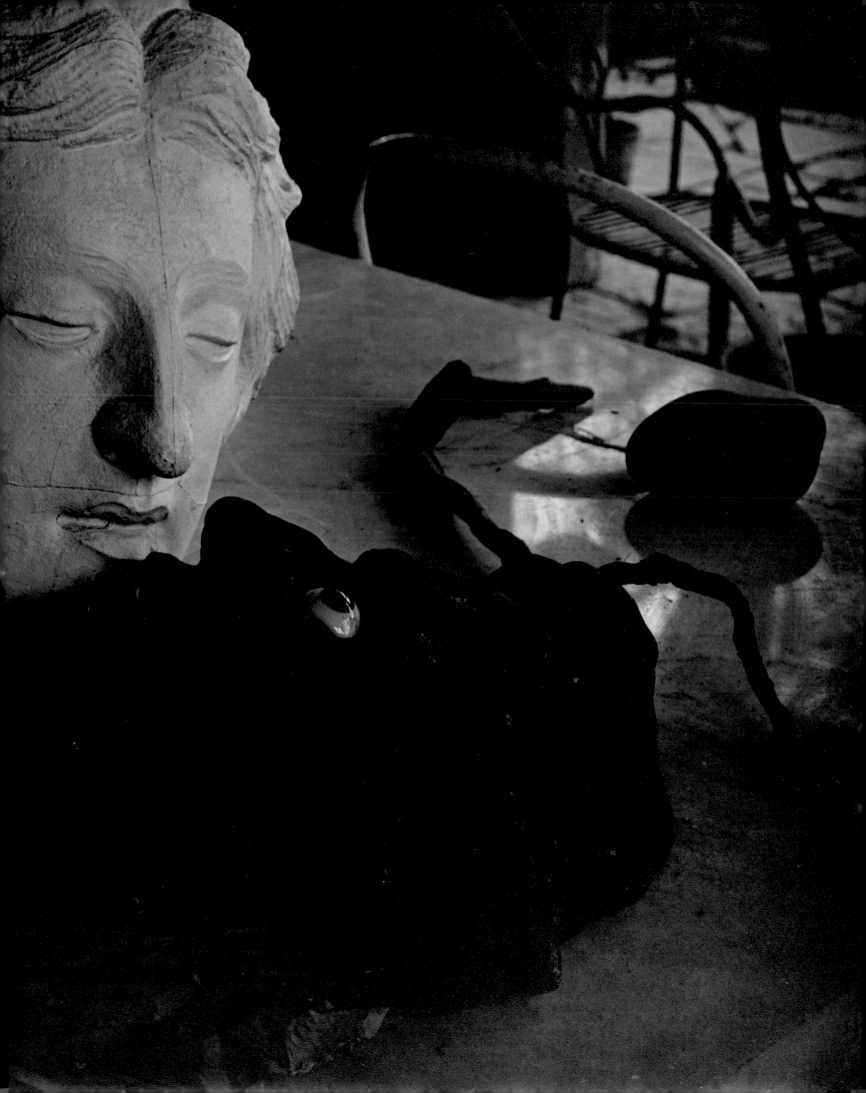

A Walk in the Magic Garden
– Rothmayer's Garden, 1954-64.

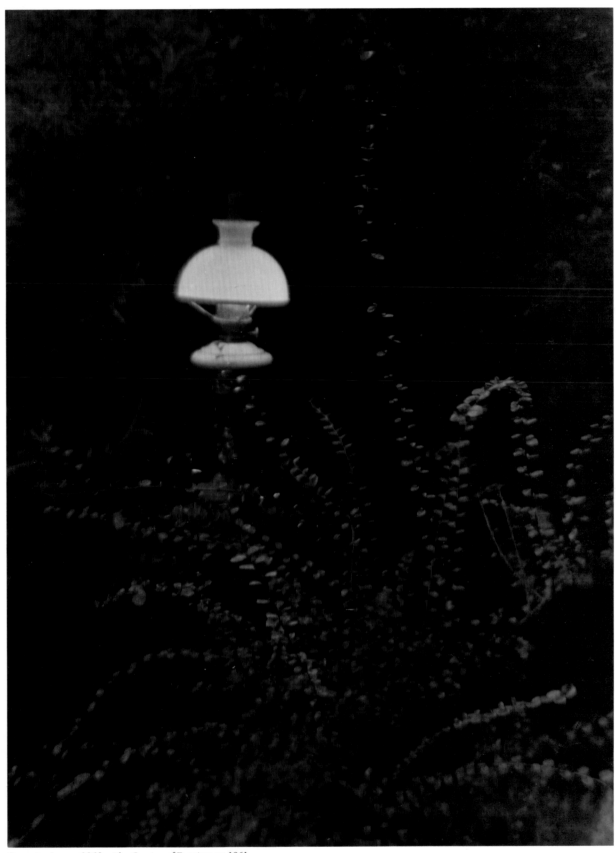

Opposite: Lovers, 1960. The Coming of Evening, ca. 1961.

I don't have many people in my photographs, especially in the landscapes. To explain this, you see, it takes me a while before I prepare everything. Sometimes there are people there, but before I'm ready they go away, so what can I do, I won't chase them back.

Vanished Statues in Mionší, 1969.

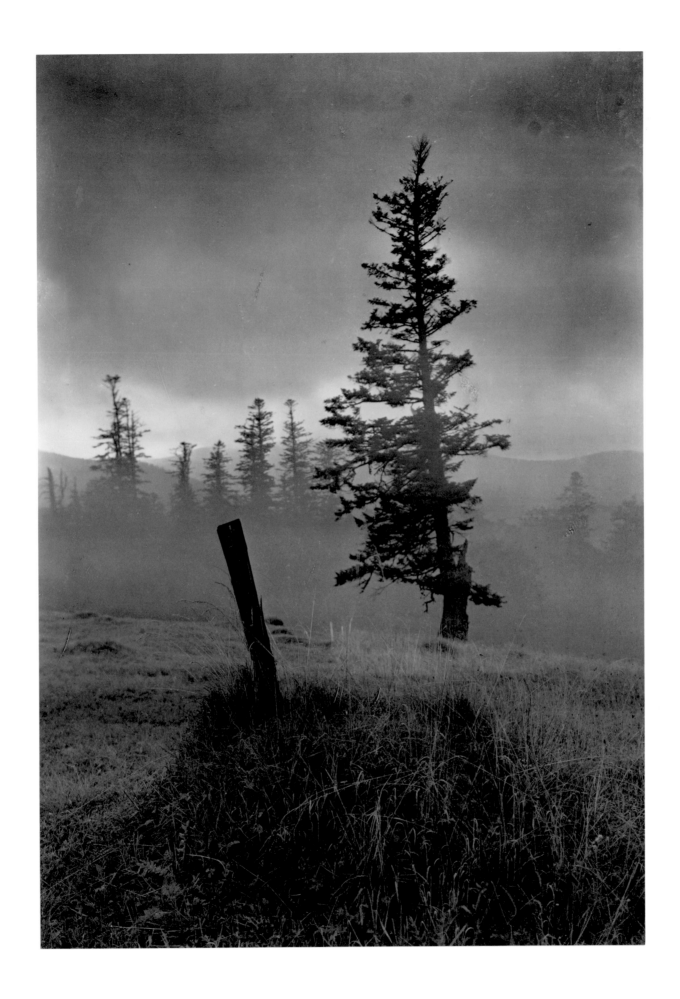

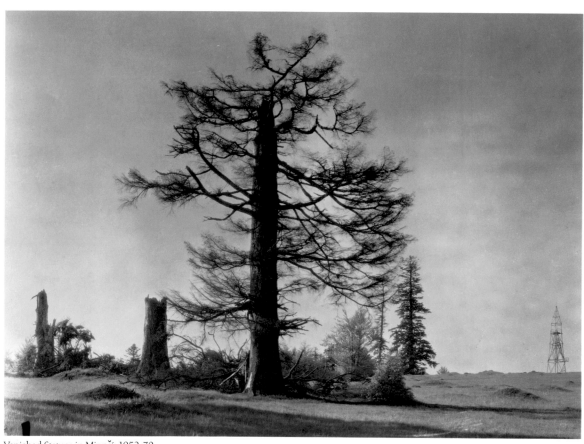

Vanished Statues in Mionší, 1952-70.

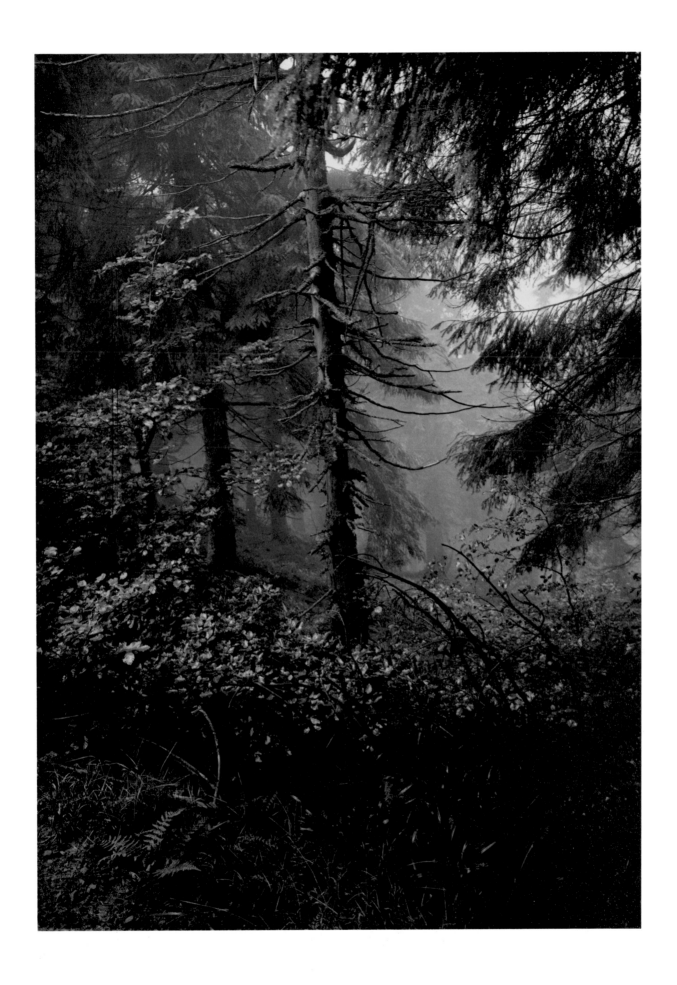

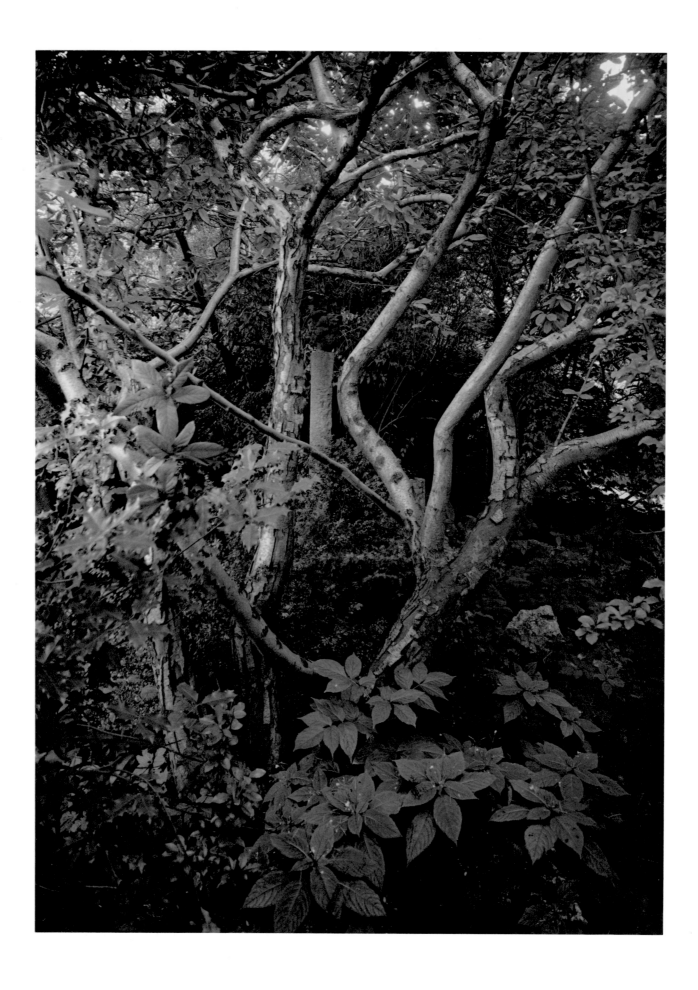

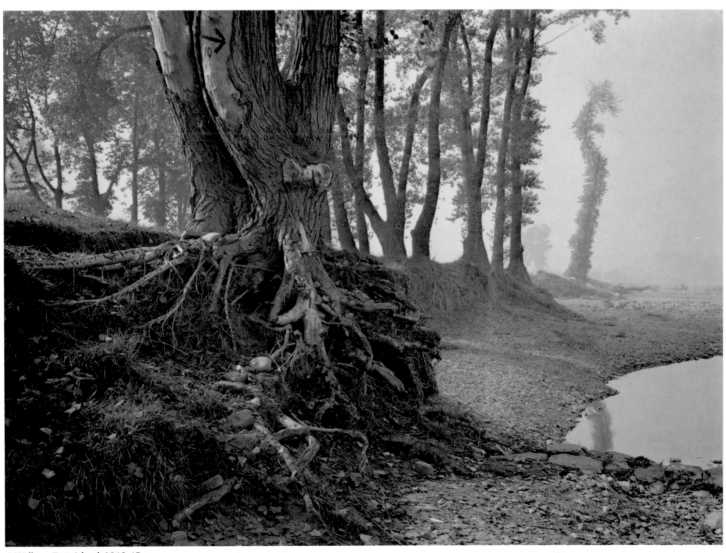

A Walk on Troja Island, 1940-45.

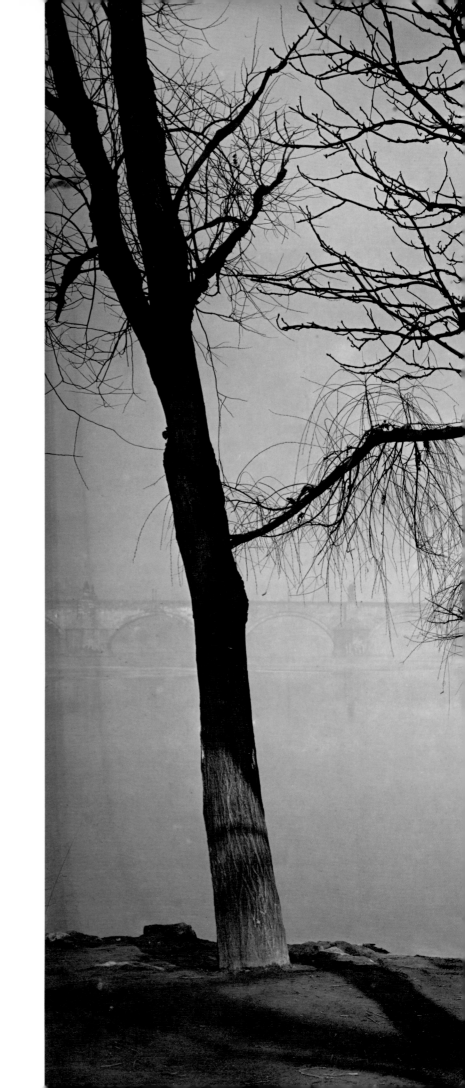

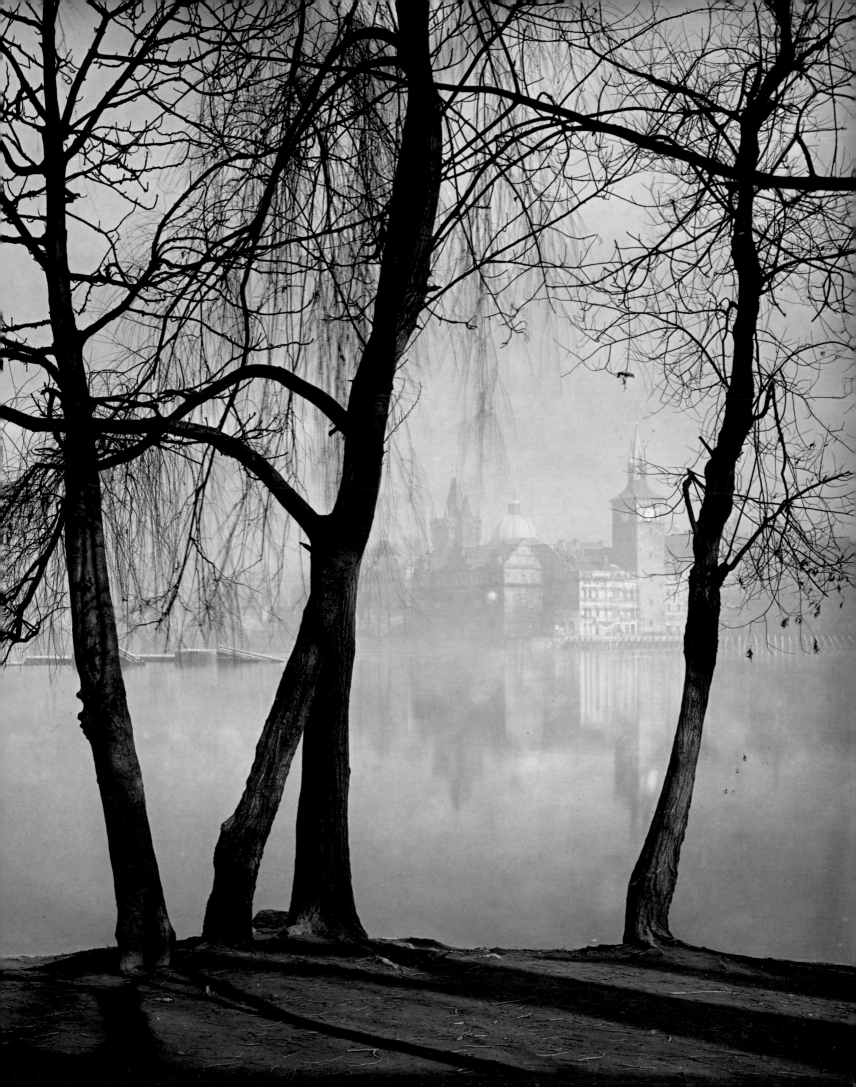

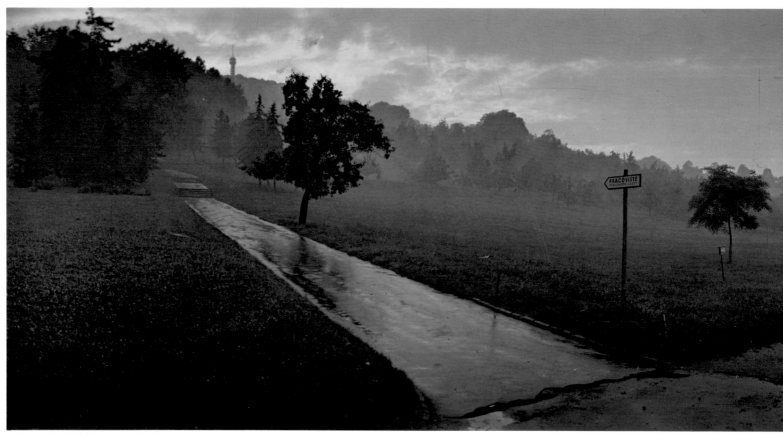

Early Evening in the Seminary Garden.

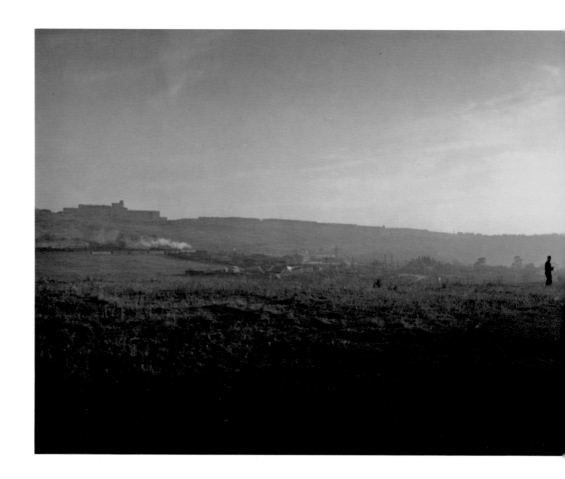

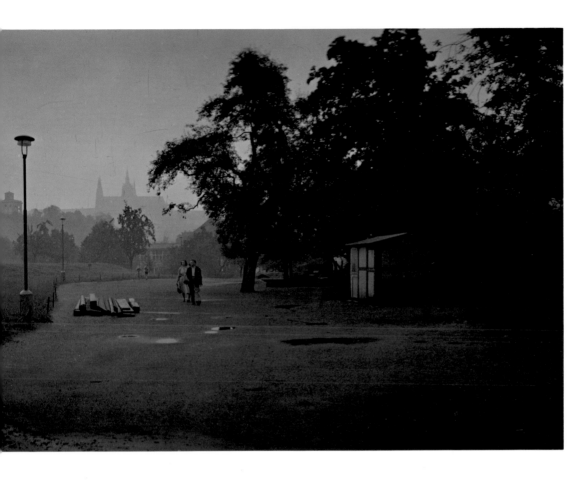

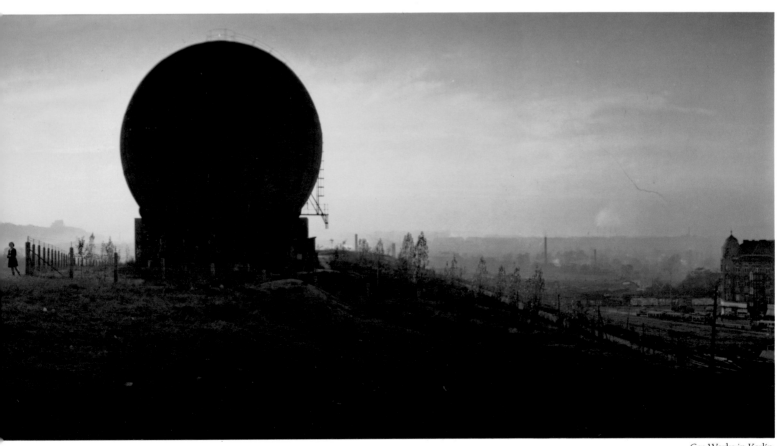

Gas Works in Karlín.

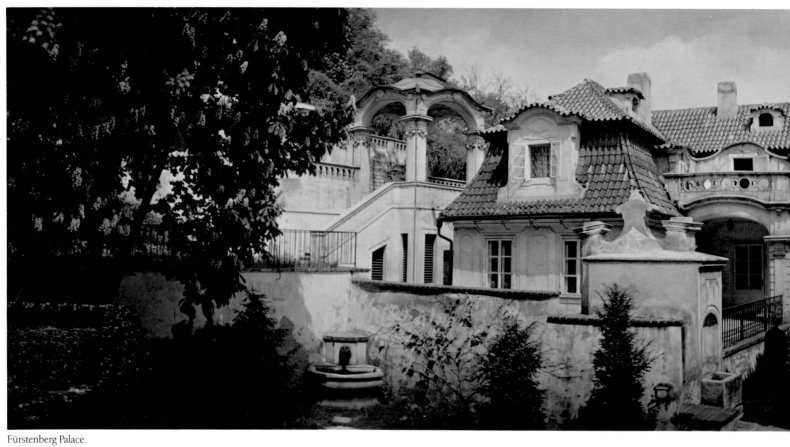

Fürstenberg Palace.

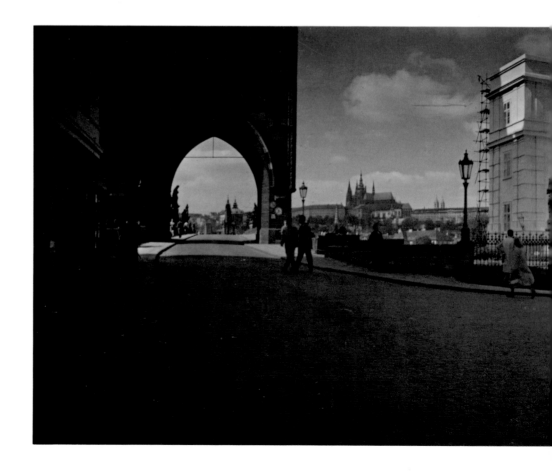

Křižovnické Quay.

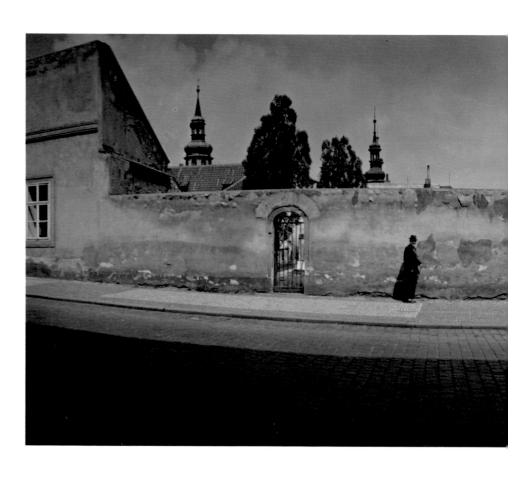

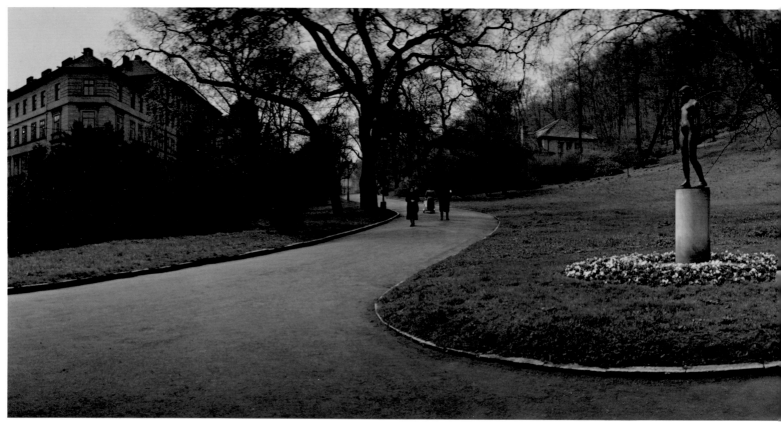

Spring in the Kinský Garden, 1948-54.

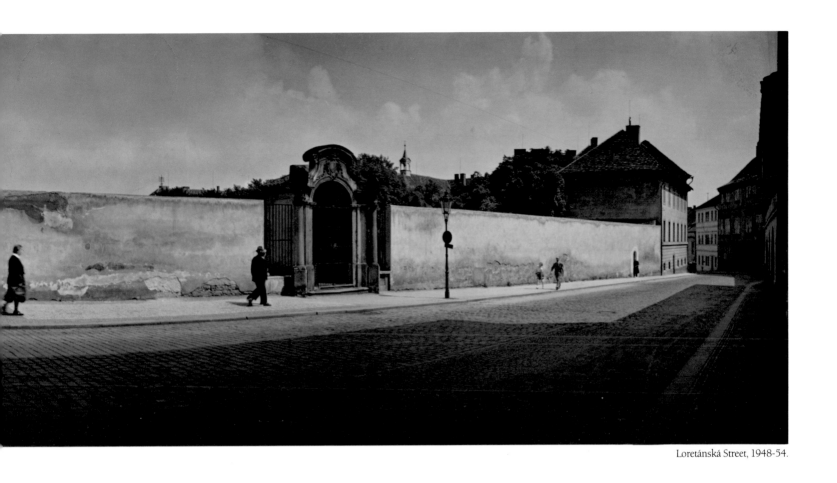

Loretánská Street, 1948-54.

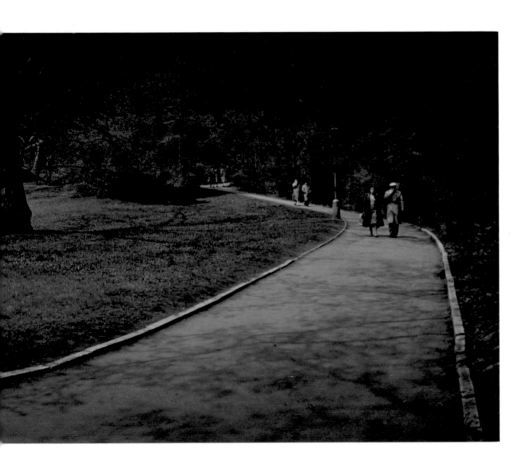

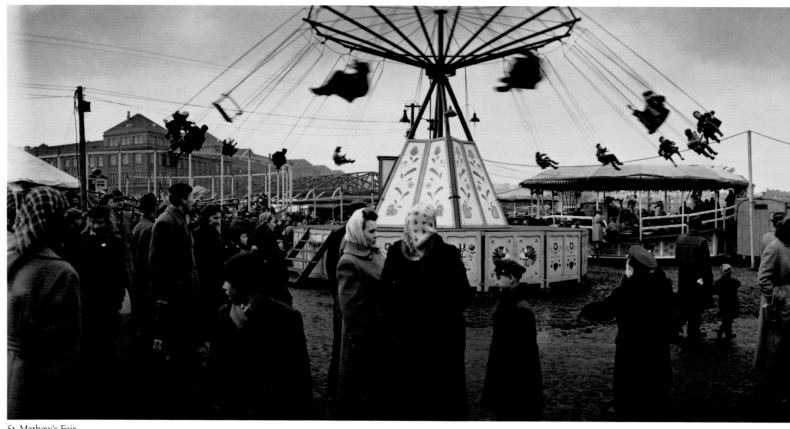

St. Mathew's Fair.

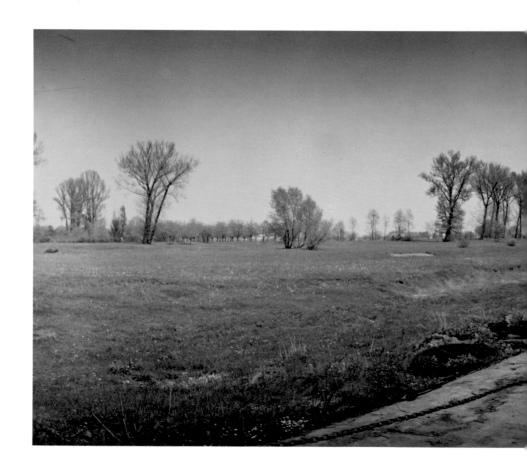

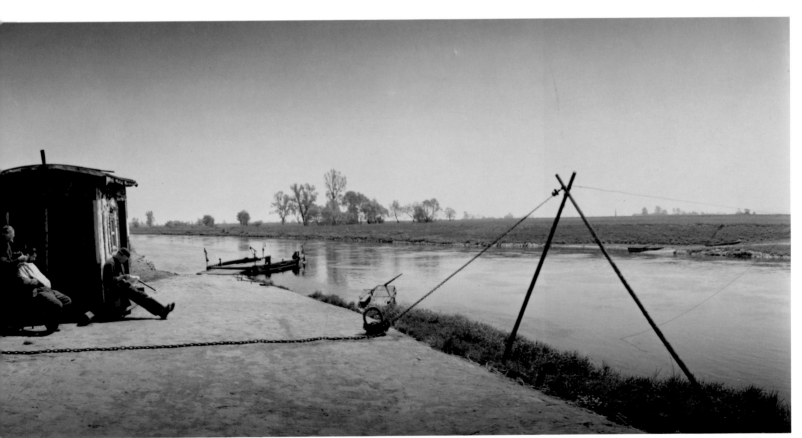

At the Ferry.

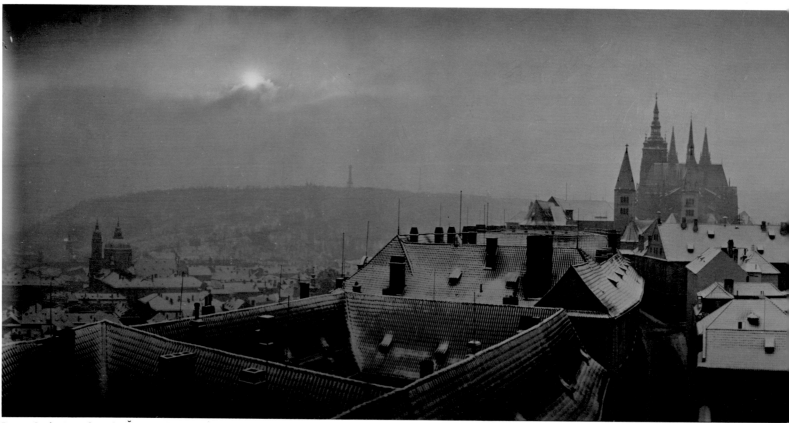

Prague Castle – View from the Černín Palace, 1950-55.

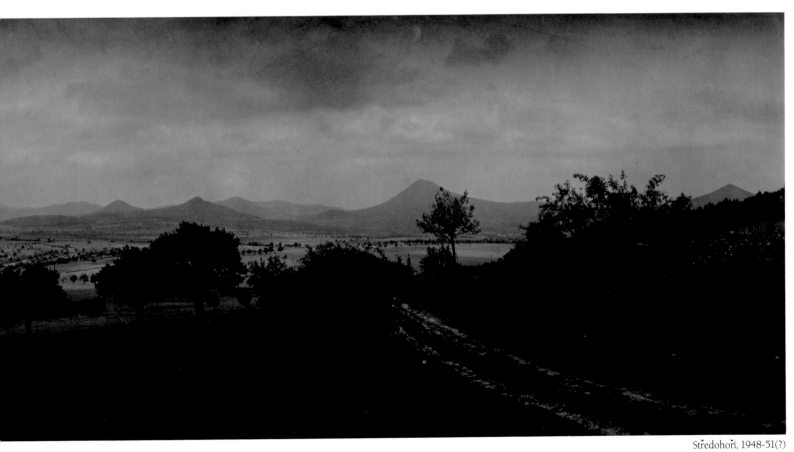

Středohoří, 1948-51(?)

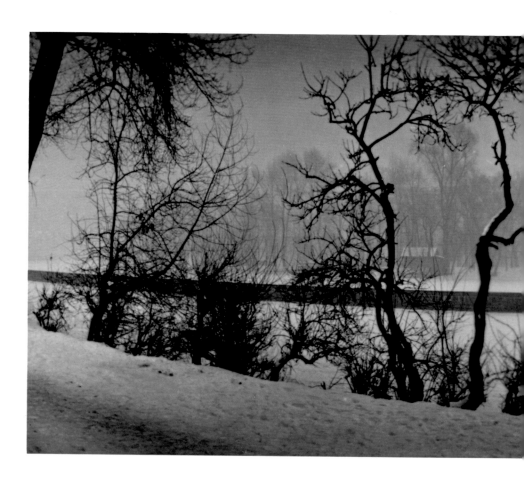

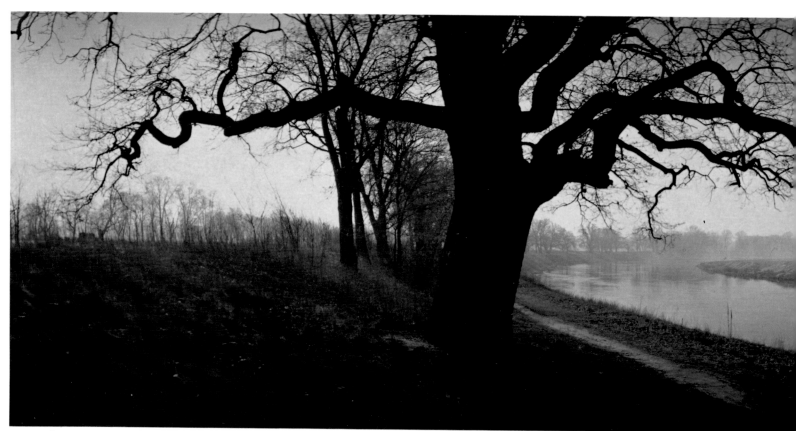

River Landscapes.

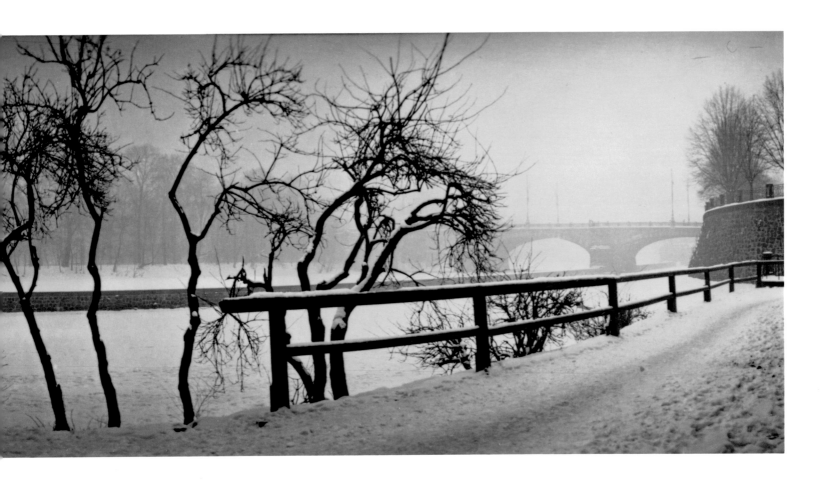

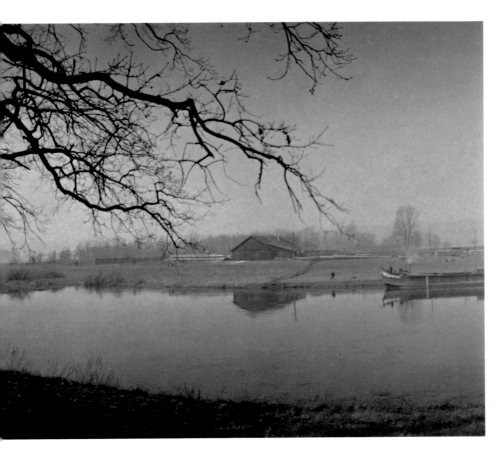

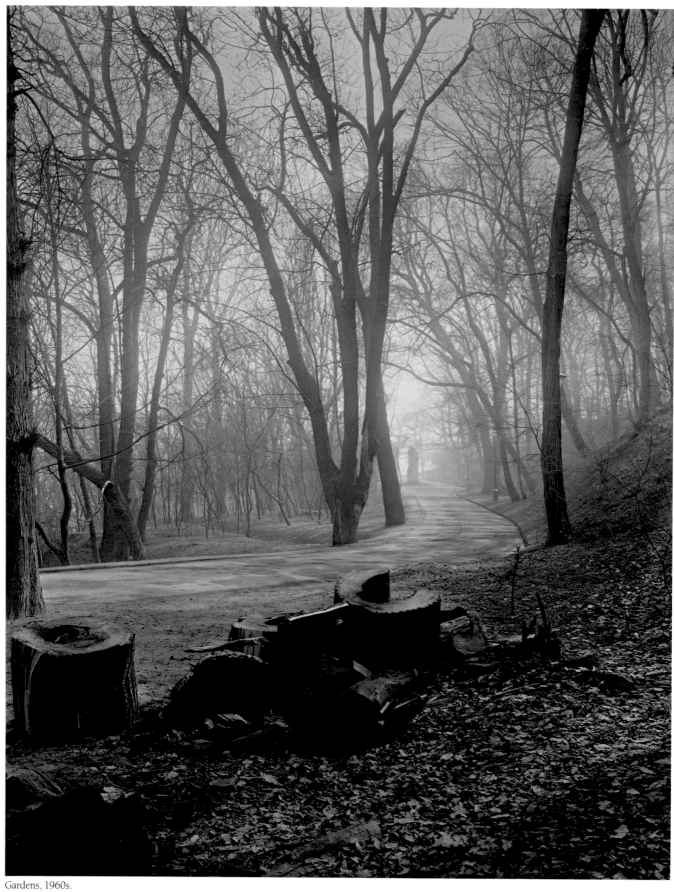

Gardens, 1960s.

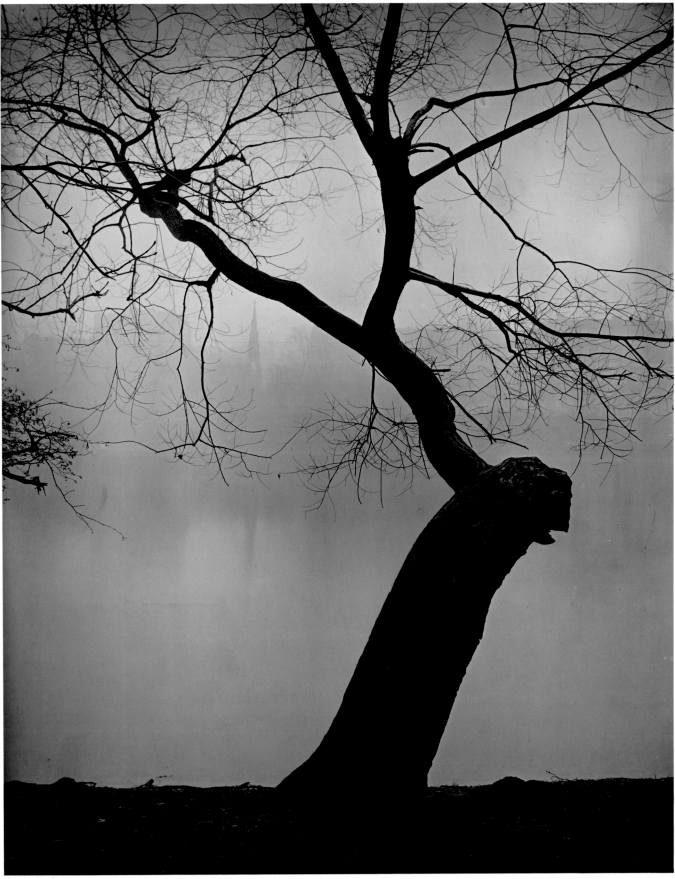

From Střelecký Island, 1946-66.

What would I be looking for when I didn't find what I wanted to find? At most I travel to Moravia to the region of Leoš Janáček, his Huk-valdy—but here I am again, talk-ing about music. In music you find everything. . . . Music has to be in-side you.

Forest Path Leading to the Lair of the Cunning
Little Vixen – Janáček-Hukvaldy, ca. 1948.

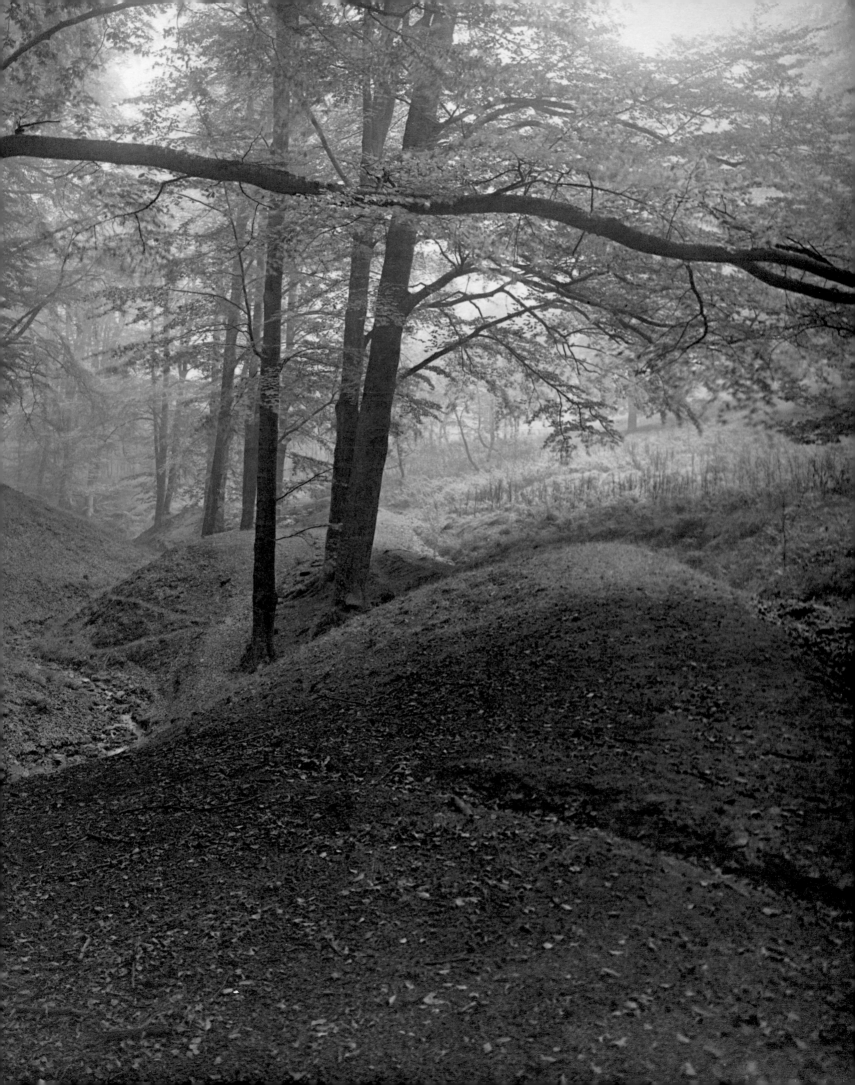

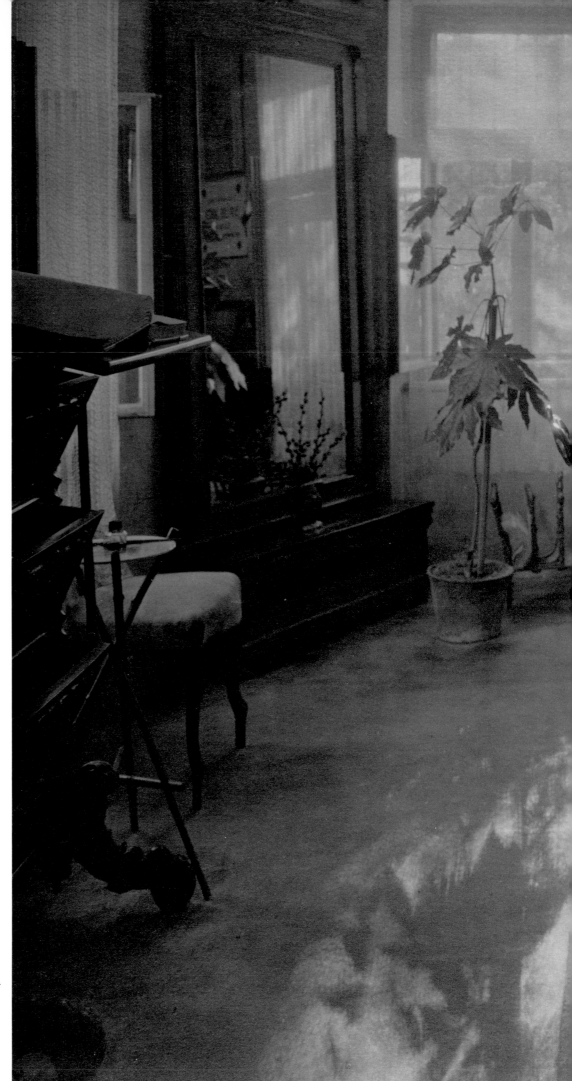

Interior—Janáček-Hukvaldy, 1948.

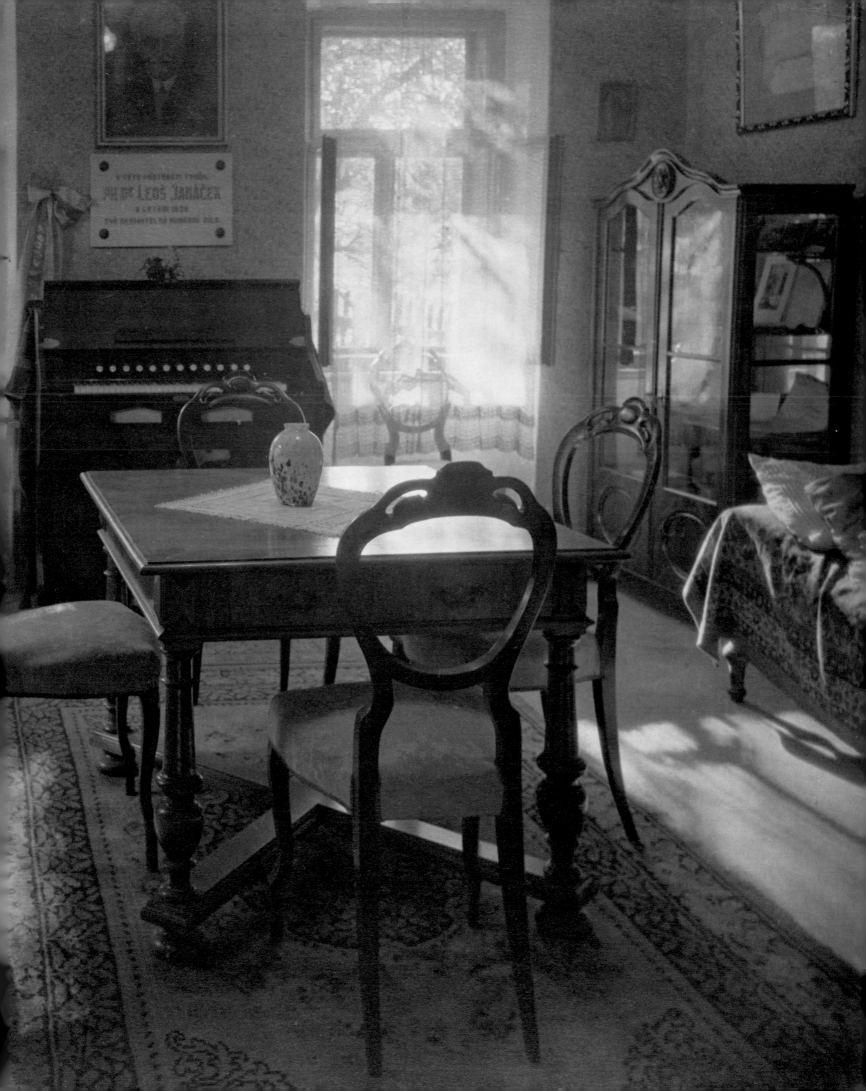

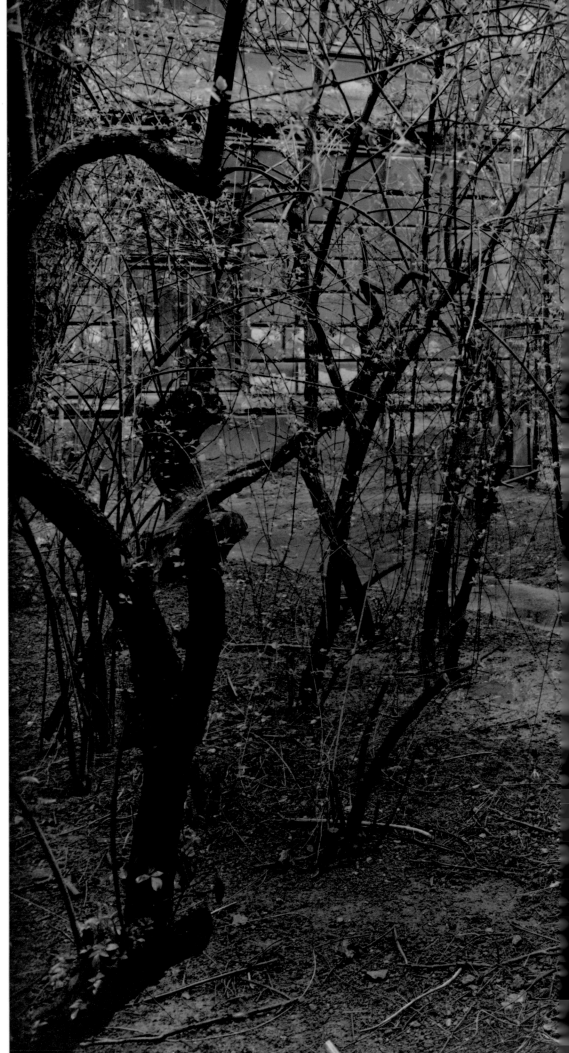

Early spring is at my window and so I go a bit to the gardens to see how spring is awakening. Till now Saint Peter has conducted everything very well and so maybe he'll succeed and it won't run away with itself too fast. . . . Maybe it's just an attack of spring fever—it will last about two weeks and after that I'll start to think straight again.

My Garden.

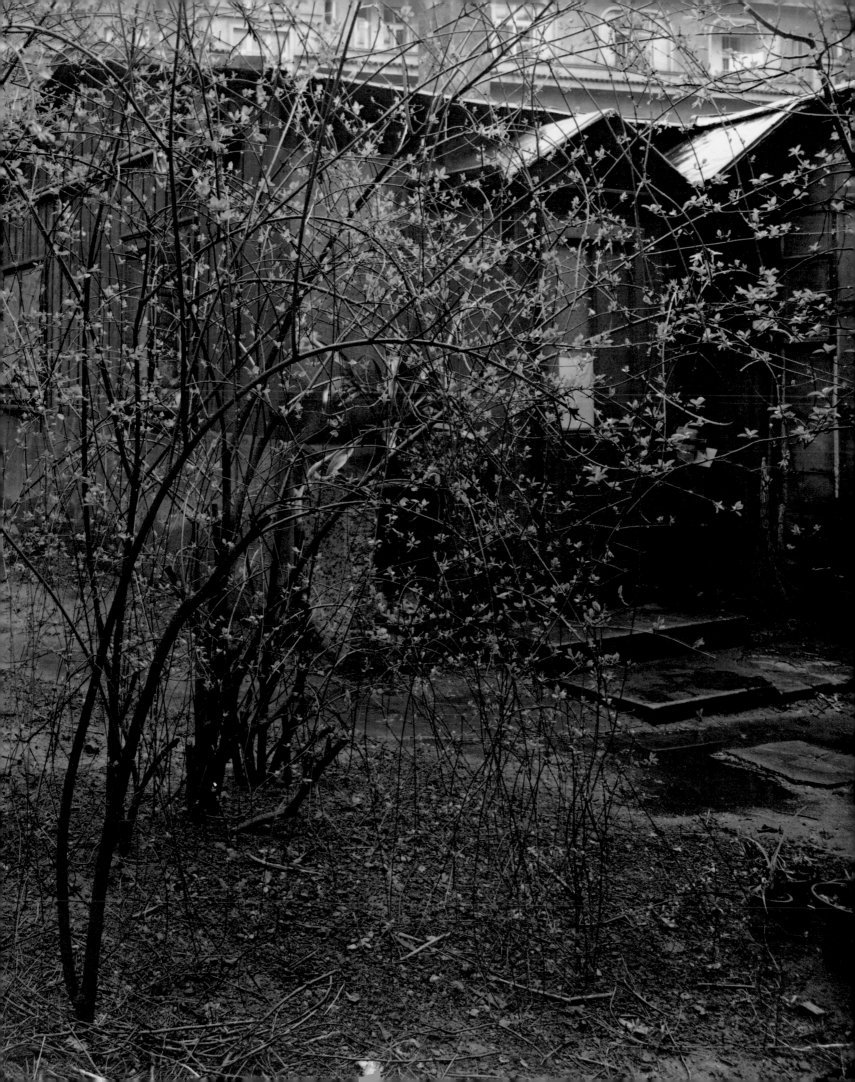

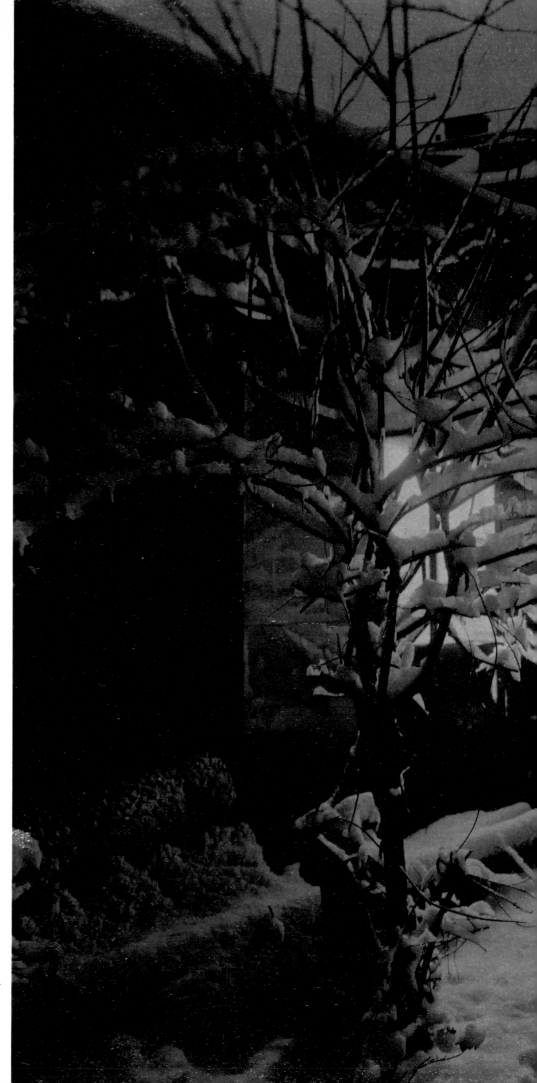

My Studio, 1950-54.

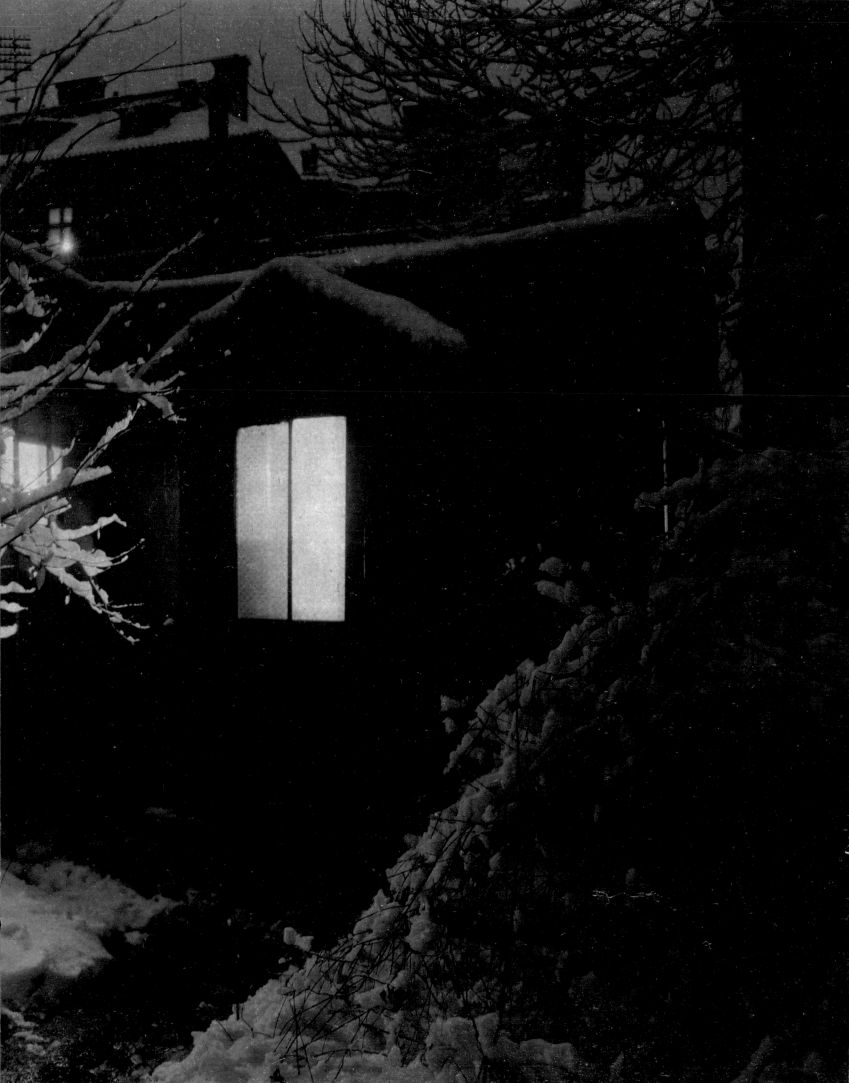

Afterword

I met Josef Sudek for the first time soon after World War II when my father, a musicologist, brought me along to one of Sudek's famous "music Tuesdays." Every week for many years, about fifteen of Sudek's artist friends crowded into his incredibly cluttered studio and listened to music from his extraordinary record collection. Sudek was an integral part of the cultural life in Prague, peppering it with his artistic personality as well as his unusual appearance: he reminded me of the gargoyles of St. Vitus cathedral, of the baroque statues on the Charles Bridge.

Over the years, as I began to feel closer to Sudek and protective of his privacy, I was a guide and interpreter to many visitors interested in his work. Slowly, unwittingly, I became more deeply involved in the story of Sudek's life, and eventually his death. Whenever he looked at me, stressing the point with the forefinger of his one hand, he would say "One day, this will be a lot of work for thee." In 1976, I organized a retrospective exhibition honoring Sudek's eightieth birthday, and our friendship grew even stronger. When he died later that year, I found myself not only taking care of Sudek's burial, but also helping his ailing sister, Božena Sudkova. Professionally, my involvement was even more unpredictable and demanding.

My first task was to go through the chaotic and nearly impenetrable layers of material accumulated in Sudek's second studio at Úvoz. From this work emerged a valuable contribution, donated to Prague's Museum of Decorative Arts in the name of Sudek's sister. In 1985, the photographer's original studio at Újezd began collapsing; then fire broke out. After that incident, I realized that the archival contents of the studio could only be saved through my intervention. During the following three years of salvaging, cleaning, and sorting the overwhelming amount of material, I discovered many new details of Sudek's life from old papers, photographs, and documents.

I've spent the last twelve years researching and classifying the contents of Sudek's two studios, deciphering his legacy. Since 1977, external circumstances, or my fate, forced me to do my research unnoticed, unacknowledged, and unpublished. Professionally I did not exist, I was a nonperson. Now that I have the opportunity to speak of Sudek's life and achievements, I hope that the fruits of my research will enrich the perception of Josef Sudek as an individual gifted with talent and indomitable spirit, an artist who made a remarkable contribution to twentieth-century photography.

Anna Farova

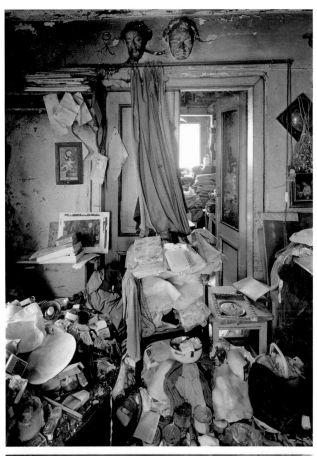

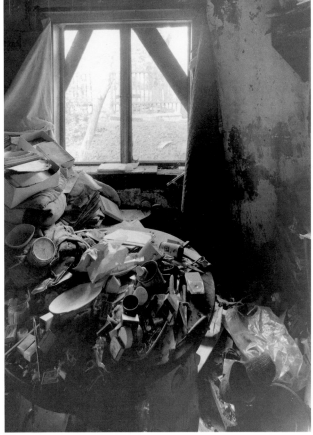

Josef Sudek's Studio at Újezd, 1985.

Bibliography

Books, Portfolios, and Calendars

1922–24 *Praha: 10 náladových fotografií* (Ten whimsical photographs). Prague: Ústřední ústav grafický, 1922–24. [Photographs signed by Sudek].

1928 Sudek, Josef. *Svatý Vít* (St. Vitus). Introduction by Jaroslav Durych. Prague: Družstevní práce, 1928. [Fifteen original silver prints, a limited edition of 120 signed and numbered copies].

1929 *Československo. Přírodní, umělecké a historické památnosti.* Vol 1. *Praha.* (Czechoslovakia. Natural, artistic, and historical monuments. Vol. 1. Prague). Photographs by Josef Sudek, graphic design by Slavoboj Tusar. Prague: Melantrich, 1929. [Published also in seven soft-bound issues, Prague, 1929].

1930 *Orbis A. S. 1931.* Prague: Orbis, 1930. [A calendar with twelve photographs of Prague, and a photo-montage on the cover by Josef Sudek].

1932 *Kalendář Družstevní práce 1933.* (A calendar of the work cooperative Družstevní práce). Prague: Družstevní práce, 1932. [Twenty-seven photographs by Josef Sudek, selected and arranged by Ladislav Sutnar from the series Česká Galerie, no. 6. Photogravure V. Nojbert].

1933 *Josef Sudek—Vánoce 1933* (Christmas 1933). Prague: Družstevní práce, 1933. [A set of twelve postcards. Česká Galerie no. 10].

1938 Novák, Arne. *Praha barokní* (Baroque Prague). Prague: František Borový, 1938. [Published in Czech, English, and French editions. Eighteen photographs by Sudek, thirteen photographs by students at the State Graphic School].

1939 *Zemský ráj to na pohled . . .* (The earthly paradise . . .). Prague: Exportní ústav pro Čechy a Moravu, 1939. [A calendar for the year 1940 with twelve photographs by Josef Sudek. German edition *Ein Paradies auf Erden,* 1939].

1939 *Praze 1939* (To Prague 1939). Lis Knihomilův, vol. 7. [Edition of 150 numbered copies. Photographs by Josef Sudek, printed by photogravure.]

1943 Wirth, Zdeněk. *Pražské zahrady* (Prague gardens). Prague: Václav Poláček, 1943. [Published in one hard-bound volume, and two paperback volumes. Photographs by Josef Sudek and others].

1943 *Moderní česká fotografie: Album deseti původních snímků* (Modern Czech photography: An album of ten original prints). Prague: Národní práce, 1943. [Ten original prints by Sudek, Ehm, Funke, Hák, and Plicka, published in a numbered edition of fifty copies].

1945 Sudek, Josef, and Rouček, Rudolf. *Pražský Hrad: Výtvarné dílo staletí v obrazech Josefa Sudka* (Prague Castle: The artistic creation of centuries in the images of Josef Sudek). Text by Rudolf Rouček. Prague: Sfinx, 1945. [First edition of 1945 included 105 photographs by Josef Sudek, second edition of 1947 contained 113 photographs].

1945 *Pražský kalendář: Kulturní ztráty Prahy 1939–45* (Prague calendar: The cultural losses of Prague 1939–45). Photographed by Josef Sudek. [Fifty-two photographs, and a cover picture].

1946 Kubíček, Alois. *Pražské paláce* (The palaces of Prague). Prague: Václav Poláček, 1946. [Czech and English editions. *Memorials of Art,* 8. 108 photographs by Josef Sudek].

1947 Sudek, Josef. *Magic in Stone.* Text by Martin S. Briggs. London: Lincoln-Praeger Publishers, 1947. [113 photographs identical with the second edition of *Prague Castle*].

1947 Novák, Arne. *Praha barokní* (Baroque Prague). Prague: F. Borový, 1947. [Second edition published in English. Fourth Czech edition included thirty-one photographs by Josef Sudek].

1948 Wenig, Adolf, and Sudek, Josef. *Náš Hrad* (Our Castle). Prague: J. R. Vilímek, 1948. [Second edition of Wenig's text with forty-eight photographs by Josef Sudek].

1948 Sudek, Josef. *Praha* (Prague). Editor of the textual part Vítězslav Nezval, preface by Arnošt Klíma. Prague: Svoboda, 1948. [128 photographs].

1949 *Toulky hudební Prahou* (Wanderings through musical Prague). Prague: Orbis, 1949. [Thirty-two photographs by Josef Sudek and other photographers].

1956 Linhart, Lubomír. *Josef Sudek: Fotografie* (Josef Sudek: Photographs). Prague: SNKLHU, 1956. [232 photographs, text by Lubomír Linhart, poems by Vladimír Holan and Jaroslav Seifert].

1958 Denkstein, Vladimír; Drobná, Zoroslava; and Kybalová, Jana. *Lapidarium Národního musea* (Lapidarium of the National Museum). Prague: SNKLHU, 1958. [176 photographs by Josef Sudek].

1958 Masaryková, Anna. *Josef Mařatka.* Prague: SNKLHU, 1958. [128 photographs of sculpture, twenty-seven reproductions, and twenty-four documentary photographs by Josef Sudek].

1959 Sudek, Josef. *Praha panoramatická* (Panoramas of Prague). Prague: SNKLHU, 1959. [284 panoramic photographs, introductory poem by Jaroslav Seifert].

1959 *Centrotex 1960.* Prague: Centrotex, 1959. [A calendar with fourteen panoramic photographs by Josef Sudek].

1961 *Pražské ateliery* (Prague studios). Prague: Nakladatelství Československých výtvarných umělců, 1961. [Featured ten artists' studios with photographs by Josef Sudek].

1961 Sudek, Josef, and Poche, Emanuel. *Karlův most ve fotografii* (Charles Bridge in photographs). Prague: SNKLHU, 1961. [Two introductory poems by Jaroslav Seifert, 160 photographs by Josef Sudek].

1962 *Josef Sudek.* Introductory text by Jan Řezáč. Prague: Orbis, 1962. [A set of twelve postcards, published in the series Profily].

1963 Strnadel, Josef. *Vyhnal jsem ovečky až na Javorníček* (I led the sheep up the mountain . . .). Prague: Státní pedagogické nakladatelství, 1963. [Twenty-two photographs by Josef Sudek].

1964 *Sudek.* Text by Jan Řezáč, photographs selected by Jan Řezáč and Josef Prošek. Prague: Artia, 1964. [Ninety-five photographs by Josef Sudek. Text in German, English, and French].

1966 Durbaba, Oldřich, and Budík, Jan. *Hudební výchova* (Music education). Prague: Státní pedagogické nakladatelství, 1966. [Polish edition *Wychowanie Muzyczne* published in 1970].

1969 Sudek, Josef. *Mostecko–Humboldtka.* Text by E. Juliš and D. Kozel. Most: Dialog, 1969. [A set of eleven panoramic postcards].

1971 Sudek, Josef. *Janáček–Hukvaldy.* Introductory text and selections from Janáček's writings by Josef Šeda. Prague: Supraphon, 1971. [Text in Czech, German, and English. 124 photographs].

1972 *Josef Sudek–10 Photographs 1940–1972.* Cologne: Galerie Rudolf Kicken, 1972. [Edition of fifty-seven numbered portfolios, each containing ten prints from original negatives].

1976 *Josef Sudek.* Introduction by Petr Tausk. Prague: Pressfoto, 1976.

1978 Bullaty, Sonja. *Sudek.* Introduction by Anna Fárová. New York: Clarkson N. Potter, 1978. Second edition 1986. [Seventy-six photographs].

1980 *Josef Sudek. Profily z prací mistrů československé fotografie,* 1. Text Petr Tausk. Selection of photographs J. Prošek, P. Zora, and P. Tausk. Prague: Panorama, 1980.

1981 Nezval, Vítězslav. *Pražský chodec: Fotografoval Josef Sudek* (Strolling through Prague: Photographed by Josef Sudek). Prague: Československý spisovatel (Slunovrat), 1981. [Thirty-two photographs. Epilogue to the fourth edition by Jan Řezáč].

1982 Kirschner, Zdeněk. *Josef Sudek: Výběr fotografií z celoživotního díla* (Josef Sudek: Selection of photographs from the oeuvre). Photographs—Personalities. Prague: Panorama, 1982. Second edition 1986. [157 photographs].

1982 Mrázková, Daniela, and Remeš, Vladimír. *Josef Sudek.* Leipzig: Fotokino Verlag, 1982. [Ninety-one photographs].

1983 Anna Fárová. *Josef Sudek.* Milan: Gruppo Editoriale Fabbri, 1983. [Fifty-seven photographs]. From the book series, "I Grandi Fotografi."

1984 Nezval, Vítězslav. *Der Praeger Spaziergänger* (Strolling through Prague). Berlin: Verlag Volk und Welt, 1984. [Eleven photographs].

1985 Porter, Allan. *Josef Sudek: Photothek.* Translated by Dieter W. Portmann. Zurich: U. Baer Verlag, 1985.

Selected one-person and group exhibitions and catalogs

1921 *Český klub fotografů amatérů v Praze: 12..členská výstava uměleckých fotografů* (Czech Club of Amateur Photographers in Prague: 12th members' exhibition of art photographers). Catalog and text by A. Škarda. Prague, 16 October–2 November.

1923 *2. výstava Českého klubu fotoamatérů v Českých Budějovicích* (2nd exhibition of the Czech Club of Amateur Photographers in České Budějovice). Catalog and text V. Burger. České Budějovice: Městské muzeum.

1923–24 *1. výstava Svazu čs. klubu fotografů amatérů v Praze* (1st exhibition of the Association of the Czechoslovak Club of Amateur Photographers in Prague). Catalog and text by V. Fanderlík. Prague: Krasoumná jednota pro Čechy v Praze, December 1923–January 1924.

1926–27 *Česká fotografická společnost: 1. členská výstava* (Czech Photographic Society: 1st members' exhibition). Catalog and text by Adolf Schneeberger. Prague, 19 December, 1926–2 January, 1927.

1932 *Josef Sudek.* Prague: Krásná jizba Družstevní práce. Travelling exhibition. Opening dates: Prague, 15 October, 1932; Bratislava, 25 March, 1933; Chrudim, 24 April.

1938 *Členská výstava fotosekce SVU Mánes* (Members' exhibition of the photo-section SVU Mánes). Catalog and text by L. Linhart. Prague.

1958 *Josef Sudek.* Catalog and text by J. Řezáč. Prague: Alšova síň Umělecké besedy.

1959 ———. Catalog by Jan Ruška. Vysoké Mýto: Okresní galerie.

1961 *Josef Sudek.* New York: Bullaty-Lomeo Studio.
———. Catalog with an introduction by R. Skopec. Opava: Slezské muzeum.
Fotografie Josefa Sudka a kresby Václava Sivka. (Photographs by Josef Sudek and drawings by Václav Sivko). Catalog and text by Jiří Kotalík. Frenštát pod Radhoštěm.

1963 *Josef Sudek.* Catalog and text by Jan Řezáč. Prague: Výstavní síň nakladatelství Československý spisovatel.

1966 ———. Catalog and text by Karel Dvořák. Liberec: Severočeské muzeum.

1968 *Five Photographers: An International Invitational Exhibition.* Lincoln, Nebraska: University of Nebraska, The Sheldon Memorial Art Gallery, 7 May–2 June.

1971 *Československá fotografie 1968–70 ze sbírek Moravské galerie v Brně* (Czechoslovak photography 1968–70 from the collection of the Moravian Gallery in Brno). ["Výstavní medailon," a section with twenty-one photographs by Sudek, in honor of his seventy-fifth birthday]. Brno: Moravská galerie.

1972 *Josef Sudek.* New York: The Neikrug Gallery, opening date 17 March.

1973–74 *Osobnosti československé fotografie* (Personalities of Czechoslovak photography). Catalog and text by Anna Fárová. Roudnice nad Labem: Galerie výtvarného umění; Prague: Uměleckoprůmyslové muzeum; Brno: Dům umění.

1974 *Josef Sudek: A Retrospective Exhibition.* Rochester, New York: International Museum of Photography, George Eastman House, 8 May–30 June.
Josef Sudek. New York: Light [Gallery], 5 March–30 March.

1974–75 ———. Washington, D.C.: Corcoran Gallery of Art, 7 December, 1974–6 January, 1975.

1976 *Josef Sudek: Souborná výstava fotografického díla* (Josef Sudek: A retrospective exhibition of photographic oeuvre). Catalog and text by Antonín Dufek. Brno: Moravská galerie, 9 April–16 May.
Fotograf Josef Sudek (Photographer Josef Sudek). (In honor of Sudek's eightieth birthday). Catalog and text by Anna Fárová. Prague: Uměleckoprůmyslové muzeum, opening date 22 April, 1976. Roudnice, August.
Josef Sudek. Catalog by Rudolf Kicken and Wilhelm Schürmann, Edition Lichttrophen. Aachen: Neue Galerie Sammlung Ludwig, September–October, 1976. Travelled to Bochum: Museum Bochum; Zurich: Kunsthaus Zurich; and Vienna: Künstlerhaus Wien.
Fotografie Josefa Sudka (Photographs by Josef Sudek). Olomouc: Divadlo hudby, 15 September–4 October.

1977 *Josef Sudek Retrospective: 1896–1976.* New York: International Center of Photography, 12 May–3 July.
Documenta 6. Catalog and text by Klaus Honnet and Evelyn Weiss. Kassel: Museum Fridericianum, 24 June–2 October.
Concerning Photography. Catalog and text by Jonathan Bayer and others. London: The Photographer's Gallery, 6 July–27 August, 1977. Travelled to the Spectro Workshop, Newcastle upon Tyne.
Panoramic Photography. Essay by Diana Edkins. New York: Grey Art Gallery and Study Center, New York University 1977.

1978 *Josef Sudek a výtvarné dílo* (Sudek's photographs, and his art collection). Text by Václav Formánek. Prague: Národní galerie.
Josef Sudek. Geneva: Canon Photo Gallery.
———. Chicago, Illinois: Allan Frumkin Gallery.
Tusen och En Bild/1001 Pictures. Stockholm: Moderna Museet.

1979 *Photographie als Kunst: 1879–1979* (Photography as art: 1879–1979). Innsbruck: Tiroler Landesmuseum Ferdinandeum, 1979. Travelled to Neue Galerie am Wolfgang Gurlitt Museum, Linz; Neue Galerie am Landesmuseum Joanneum, Graz; and Museum des 20. Jahrhunderts, Vienna.
Fotografie z pozůstalosti Josefa Sudka. (Photographs from Josef Sudek's estate). Text by Zdeněk Kirschner. Prague: Uměleckoprůmyslové muzeum.

1981 *Josef Sudek.* Daytona Beach, Florida: Daytona Beach Community College Gallery of Fine Arts, 15 May–5 June.
Josef Sudek: Zahrady (Josef Sudek: Gardens). Catalog and text Zdeněk Kirschner. Prague: Uměleckoprůmyslové muzeum; Liberec: Okresní kulturní středisko, 25 June–19 July, 1981.
Josef Sudek. Los Angeles, California: Stephen White Gallery, 15 September–17 October.
———. Toulouse: Galerie Municipale du Château d'Eau, October.

1982 *Josef Sudek, 1896–1976.* Chicago: Jacques Baruch Gallery, 23 February–3 April.
The Contact Print. Catalog by James Alinder. Carmel, California: Friends of Photography.

1982–86 *Josef Sudek: Cykly fotografií.* (Josef Sudek's photographic series. Exhibitions from the collection of the Museum of Decorative Arts in Prague). Five exhibitions and catalogs by Zdeněk Kirschner. Státní zámek Kozel, June, 1982; May–June, 1983; September–October, 1984; September–October, 1985; September–October, 1986.

1983 *Saudek/Sudek: Images From Czechoslovakia.* Iowa City: The University of Iowa Museum of Art, 5 February–3 April.
Fotografie Josefa Sudka a Jana Svobody (Photographs by Josef Sudek and Jan Svoboda). Komparace I. Catalog by Zdeněk Kirschner. Roudnice nad Labem: Galerie výtvarného umění, 14 April–22 May.
Photographes tchèques 1920–1950 (Czech photographers 1920–1950). Catalog by Zdeněk Kirschner and A. Dufek. Organized by the Museum of Decorative Arts in Prague. Paris: Musée National d'Art Moderne, Centre Georges Pompidou, 8 July–4 September.

1986 *Josef Sudek: The Poet of Prague.* New York: Ledel Gallery, 5 March–29 March.

1987 *Josef Sudek/Jaromír Funke/Adolf Schneeberger: Photographs From Czechoslovakia 1919–1970's.* Chicago: Jacques Baruch Gallery, 30 January–11 March.
Sudek–Funke. Exhibition and catalog by Zdeněk Kirschner, Státní zámek Kozel, September–October.

1988 *Josef Sudek.* Los Angeles, California: Jan Kesner Gallery, 5 February–1 March.
Josef Sudek. Organized by the Ministries of Culture of the ČSR and SSR, under the auspices of the *Arts America* program of the U. S. Information Agency. San Francisco, California: Museum of Modern Art, 15 April–29 May; Chicago: Art Institute of Chicago, 15 June–5 September.

1988–89 *Josef Sudek/Albín Brunovský.* (Photographs by Josef Sudek, prints and paintings by Albín Brunovský). Organized by the Ministries of Culture of the ČSR and SSR, under the auspices of the *Arts America* program of the U. S. Information Agency. Pittsburgh, Pennsylvania: University of Pittsburgh Gallery, 9 October–6 November, 1988; Cleveland, Ohio: Cleveland Museum of Art, 7 December, 1988–5 February, 1989.

Selected articles on Josef Sudek

Anděl, J. "Josef Sudek: Ein verdienter Künstler der ČSSR" (Josef Sudek: The Artist of Merit of ČSSR). *Fotografie* (ĐDR), no. 2 (1974): 21–27.

———. "Obrazová kvalita ve fotografiích Josefa Sudka" (Image Quality in the photographs of Josef Sudek). *Fotografie '73* 17, no. 2 (1973): 18–19.

Altschul, Pavel. "Fotograf Josef Sudek." *Žijeme* (1932): 183.

Bergerová, E. M. "Vyprávění pana Sudka ve filmu 'Fotograf a Muzika' " (Refections of Josef Sudek in the film 'A Photographer and Music'). *Fotografie '79* 23, no. 1 (1979): 53–61.

Bullaty, Sonja. " . . . and there is music." *Infinity* 18 (December 1969): 7.

———. "Sudek." *U. S. Camera Annual* (1971): n. p.

Chaloupka, Otakar. "Hovoří zasloužilý umělec Josef Sudek" [Interview with Josef Sudek, Artist of Merit]. *Československá fotografie,* no. 11 (1963): 373.

Ellis, A. "Talking of Landscape." *British Journal of Photography* 129 (March 1982): 274–5.

Fárová, Anna. "Josef Sudek." *Camera* (Lucerne) 55, no. 4 (1976): 6–37; 40–42.

Ginsberg, Paul. "Josef Sudek." *Popular Photography* 75 (November 1974): 151–2. [Review of Sudek exhibition at GEH, Rochester, N. Y.].

Goldberg, Vicki. "Josef Sudek, a Monk of Photography: Transforming the Ordinary into the Rare." *American Photographer* 2, no. 3 (March, 1979): 12; 16.

Goto, John. "The Silent Labyrinths of Mr. Sudek." *British Journal of Photography* 126 (February 1979): 128–32.

Halas, František. "Josef Sudek." *Panorama* (Czech.) 10 (September 1932): n. p.

Jedlan, J. "Josef Sudek a jeho místo v české fotografii" (Josef Sudek and his place in Czech photography). *Fotografie,* no. 1 (1976): n. p.

Jeníček, Jiří. "Josef Sudek." *Československá fotografie,* no. 3 (1955): 26–28.

Jírů, V. "Josef Sudek šedesátníkem " (Josef Sudek at sixty). *Výtvarná práce,* no. 5 (1956): n. p.

———. "Josef Sudek." *Československá fotografie,* no. 1 (1957): 5.

"Josef Sudek." *Creative Camera,* no. 109 (July 1973): 234–5.

"Josef Sudek." *Creative Camera,* no. 190 (April 1980): 126–32. [Portfolio].

"Josef Sudek–A Monograph." *Camera* (Lucerne) 55, no. 4 (April 1976). [An issue dedicated to Sudek, with major articles by Anna Fárová and Allan Porter].

"Josef Sudek: Panoramas." *Creative Camera,* no. 113 (November 1973): 364–73.

"Josef Sudek: The Birthplace of Janáček." *Creative Camera,* no. 136 (October 1975): 328–9; 348–53.

Keledjian, Chris. "Josef Sudek: An Alliance with Light." *Artweek* 12 (10 October 1981): 11. [Exhibition review—Stephen White Gallery, Los Angeles, California].

Linhart, Lubomír. "60 let Josefa Sudka" (Josef Sudek at sixty). *Československá fotografie,* no. 1 (1956): 30.

———. "Josef Sudek a Jaromír Funke." *Československá fotografie,* no. 2 (1956): 64–65.

Mašín, Jiří. "Josef Sudek 75." *Československá fotografie,* no. 3 (1971): 84.

Normile, Ilka. "Josef Sudek: A Backyard Romantic." *Afterimage* (Rochester, N. Y.) 5 (May/June 1977): 8.

Pangerl, Franz. "Böhmische Romantik Josef Sudek: Altmeister der tschechoslowakischen Fotografen" (Czech romantic Josef Sudek: Old master of Czech photographers) *Foto Magazin,* no. 10 (1971): n. p.

Pečírka, J. "Fotografie Josefa Sudka" (Photographs by Josef Sudek). *Nový život,* no. 4 (1957): 446–8.

Porter, Allan. "A Mysterious Light." *Camera* (Lucerne) 55, no. 4 (1976): 4–5; 38–39.

———. "Panoramas of the Czechoslovakian Landscape: Josef Sudek." *Camera* (Lucerne) 46, no. 7 (1967): 22–23.

———. "Sudek." *Camera* (Lucerne) 45, no. 3 (1966): 6.

Puvogel, R. "Josef Sudek." *Kunstwerk* 29 (November 1976): 84.

Ratcliff, Carter. "Josef Sudek: Photographs." *Print Collector's Newsletter* (U. S. A.) 8 (September–October 1977): 93–95.

Remeš, V. "Josef Sudek." *Fotografie '73,* no. 2 (1973): 12–17.

Řezáč, Jan. "Sudek." *Camera* (Lucerne), 45, no. 3 (1966): 6; 15.

Sage, James. "Josef Sudek: A Portfolio." *Infinity* 18 (December 1969): 6–19.

Sawyer, Charles. "Josef Sudek: The Czech Romantic." *Modern Photography* (New York) 4 (September 1976): 108–117.

"Sedmdesát let Josefa Sudka" (Josef Sudek at seventy). *Československá fotografie,* no. 2 (February 1966). [An issue dedicated to Sudek, with articles and interviews by twelve contributors, including Karel Dvořák, V. Reichmann, J. Toman, M. Novotný, and J. Řezáč].

[Sivko, Václav]. "Josef Sudek vystavoval" (Josef Sudek exhibited). *Československá fotografie,* no. 4 (1958): 132. [Václav Sivko's speech at the opening of Sudek's exhibition].

Skopec, R. "Josef Sudek: Ein Kapitel Photogeschichte" (Josef Sudek: A chapter in the history of photography). *Im Herzen Europas* (September 1964): 17–19.

———. "Výtvarný fotograf Josef Sudek" (Artistic photographer Josef Sudek). *Mladý Polygraf,* no. 9 (1963): n. p.

Spencer, Ruth. "Josef Sudek: A Tribute to His Life, His Work." *The British Journal of Photography* 123 (December 1976).

"Stilleben—Portfolio." *Du,* no 4. (1987); 100–5.

Sturman, John. "Josef Sudek." *Art News* 85 (Summer 1986): 132. [Review of the exhibition at the Ledel Gallery, New York].

Sudeberg, Erika. "The Father of European Modernism." *Artweek* 19 (March 1988): 10.

"Sudek at Work." *Creative Camera,* no. 3 (March 1975): 76.

Tausk, Petr. "Josef Sudek, ein wahrer Klassiker der tschechoslowakischen Fotografie" (Josef Sudek: A true classic of Czechoslovak photography). *Fotoprisma,* no. 4 (1970): n. p.

———. "Josef Sudek: His Life and Work." *History of Photography* 6 (January 1982): 29–58.

———. "Josef Sudek—80 let" (Josef Sudek—eighty years). *T 76,* no. 2 (1976): n. p.

———. "Josef Sudek 75-ročný" (Josef Sudek at seventy-five). *Výtvarnictvo, Fotografia, Film,* no. 4 (1971): n. p.

———. "The Roots of Modern Photography in Czechoslovakia." *History of Photography* 3 (July 1979): 253–271.

Westerbeck, C. L. "Taking the Long View." *Artforum* 16 (January 1978): 56–59.

Wigh, L. "Josef Sudek: Czech Photographer/Josef Sudek: Tjeckoslovakisk Fotograf." *Fotografiska Museet* (Sweden), nos. 3–4 (1978): 1–4.

People and Ideas

BEAUTY AND RENEWAL:
An Interview with Sonja Bullaty
by Melissa Harris

I don't remember my first meeting with Sudek. All I was aware of in those days was that a previous "normal" life was gone. My family was dead, my home was gone, most of my friends lost. There was no one and nothing to turn to, but I was alive—by some weird accident. And I knew I wanted to photograph. I eventually met Sudek—probably through a painter friend and his wife. Sudek's outlook on life was positive, and despite everything, so was mine.

Sonja Bullaty assisted Josef Sudek for over a year, beginning in 1945. She was 21, and had spent the previous four years in concentration camps.

While I helped Sudek, as his apprentice-martyr, to lug his heavy equipment over the hills of Prague, in all those months it didn't occur to me to ask him about the loss of his arm. I never realized, in any way, that he was handicapped. He wasn't—any more or less than I was. He had lost his arm and there was no way it could be replaced. What I had lost—the wound I suffered internally, psychologically—was equally deep, equally confusing. There was also no way I could replace it.

The shadows in Sudek's photographs have such presence, and are often more pronounced than their source. Do you think this may be related to the loss of his arm—a kind of overcompensation, making the absent tangible?

I'm amazed, each time I see a new photograph by Sudek, at how much of himself is in it. I think many of us who have lived through difficult times are haunted—you cannot separate this. There's no question that when you make your exposure, what comes into it is your whole life experience. As for being specifically related to his injury, well, I don't think so. Sudek was an extremely positive person, and very unneurotic. He was content to have a very simple meal, to have his beer with it—no doubt about that—and to be surrounded by his friends, do the work he believed in, and to have his music. I always took it for granted that Sudek had just picked up the pieces and gone ahead, and that's what I did. When you come back, at least you know you're living, you're alive,

and that's basically the only thing that mattered to me. And I think it was the only thing that mattered to Sudek.

Do you think that, in some ironic way, Sudek felt so alive because he had lost his arm?

I'm absolutely convinced of it. When you're so close to not being, then every day is a gift, and yes, you do wake up every day and enjoy being. Sudek's way of living was so full of joy, without rancor or resentment. That to me was also a lesson—that bitterness does not help. He never really thought about these things, though. He was opposed to thinking too much because he thought that it killed the instinct—he was extremely intelligent, of course, and articulate, but basically he relied on his feelings.

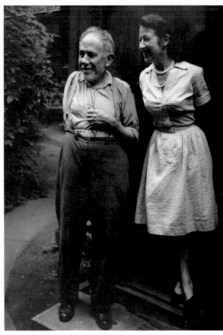

Angelo Lomeo. *Sudek and Sonja,* c. 1960

Is this where the music came in?

Sudek said that music always led him to something, and yes, of course, because it is feeling, and he let his feelings guide him. Sudek was interested in all the arts. Painting, because many of his friends were painters, was the most important influence on his work, but music was his great joy, and over the years it became more and more so, and also his solace. He loved Dvořák, Monteverdi, Vivaldi—I sent him Mozart because he was my love—and of course Janáček, his great love.

Tell me about the "music Tuesdays."

Well, chamber music was playing most of

the day, even when we were working in the darkroom, but on Tuesday evenings, you listened. It was not background music. We'd sit on the floor, or wherever, and somebody would bring new records, new releases—it could be anything.

In 1947, Bullaty came to New York to study photographic technique—something she had not learned with Sudek. She had planned to return to Prague, but met her husband, Angelo Lomeo, and stayed. Meanwhile, she and Sudek began a regular correspondence, for the most part exchanging notes on the backs of photographs. Bullaty also sent him photo supplies that he could not get in Czechoslovakia, as well as music. It wasn't until 1960 that Bullaty visited Prague, and Sudek, again.

When I finally dared to confront my past, it was a horrendous experience, but it was the best thing I ever did. I think it's the moving on that becomes terribly important, because if you dwell on things that happened, that is the end of life. This is why I feel that when I celebrate change, I celebrate life. In some ways Sudek and I believed in many of the same things.

Are you, was he in any way religious—I don't mean, necessarily, in traditional terms . . . ?

Spring and renewal. Life returns to nature and to people. That was Sudek's favorite time, when he did most of his work. Perhaps here religion might come in—in the belief, whether pagan or Christian, that nature renews itself. Sudek loved the earliest spring, the awakening of nature from a long sleep, and he would often write about it in his letters. The weather was most important. Sudek was religious in his peculiar way, in a very private way. I am not religious. But we both believed in the wonder that is this earth, that there is goodness in people, and in the wonderful feeling when one can communicate with nature and feel a part of it. This is what we shared, without words: that despite whatever happens there is beauty and renewal—that life goes on. And look at what is happening in Prague now. I didn't think I'd see it in my lifetime. The arts will flourish. We've all been waiting for it, and Sudek would have been extremely happy, because he was such a free spirit.

In 1978, Bullaty published a monograph on the photographer entitled *Sudek.*

Continued on page 160.

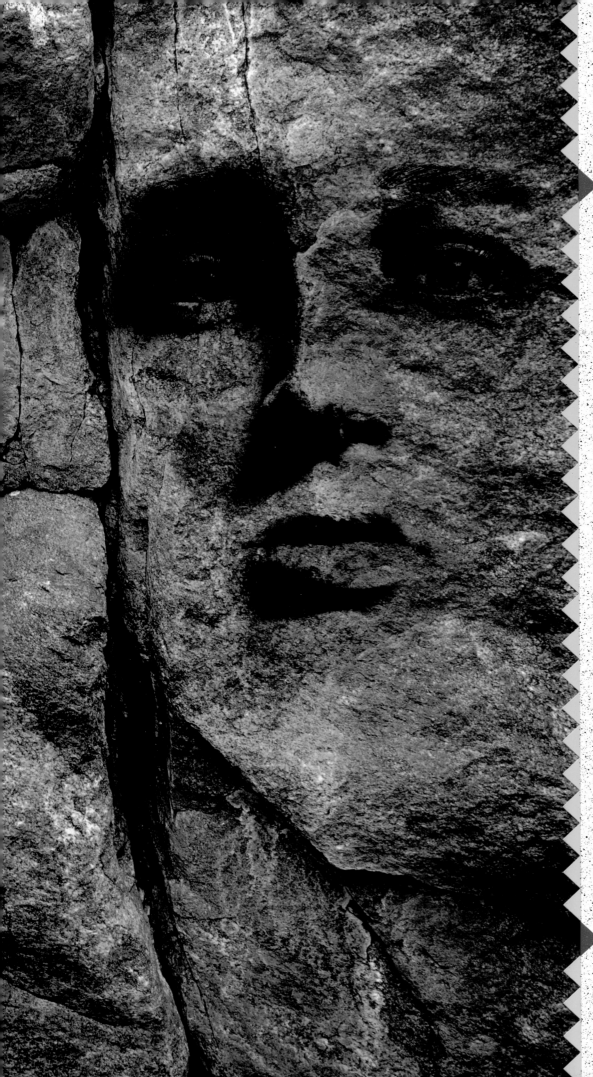

Untitled, 1985.
© Jerry Uelsmann, 1989

I love the black-and-white

THE

medium, and I still sense the

MYSTERY

same feeling of enchantment

OF

and wonder I experienced the

BLACK

first time I saw an image

AND

appear in the developer. At

WHITE

times I want to kiss the tray.

For me, black and white is a

form of alchemy, and the

process is truly magic.

JERRY UELSMANN
User of Kodak black-and-white
materials for 35 years.

The Language of
Black and White.

DARK LAUGHTER

Patrick Nagatani and Andree Tracey at Jayne H. Baum Gallery, New York, November 1989
by Charles Hagen

The sanest response to the threat of nuclear war may be to laugh—at the absurdity of the situation we have worked ourselves into, and to remind ourselves that life is in fact worth living. Of course, humor that deals with the threat of global destruction can't help but be black, as Thomas Pynchon, Kurt Vonnegut, and others have demonstrated. Since 1983 Patrick Nagatani and Andree Tracey have been making smart, funny photographic works that deal with the horrific subject of the impending nuclear holocaust. Steeped in bitter black humor, these collaborations explore stereotypes and paradoxes of the "atomic culture" that, even in an age of glasnost, continues to underlie the public life of our time.

Typically, Nagatani and Tracey create elaborate setups, complete with painted and photographic backgrounds and props, then photograph themselves and others in these theatrical settings, usually using Polaroid's 20 × 24 inch camera and print material. The backdrops and props have a slapdash quality about them, making them seem a little like sets in a high-school play; working with these playful setups Tracey and Nagatani address absurdities of contemporary life. In the past these have included such everyday annoyances as the rush-hour crush in the New York subways, but more often—and by far more effectively—their tableaux have dealt with questions of nuclear weapons and their potential for massive destruction.

On occasion the two will exhibit photographic works alongside the setups on which they're based. In their most recent New York show, for example, the pair presented both the setup and the final photographic diptych for a piece entitled *Great Yellow Father*. In the finished piece, made up of two Polaroid 20 × 24 inch prints butted together, Nagatani appears in the lower corner, trying to photograph a flock of fake fish that swarm across the sky above him. The picnic table in the background, as well as the yellow pith helmet and T-shirt Nagatani wears, sug-

gest a family outing gone a little wacko, and more than a little ominous, as the fish swarm piranhalike towards the viewer.

Without Nagatani in the picture, the flying fish become the most important figures in the work. By themselves they take on a sci-fi air, as if they were props in one of those B-movies in which the forces of nature rise up and punish the hubristic humans who dared tamper with them. In more general terms, these

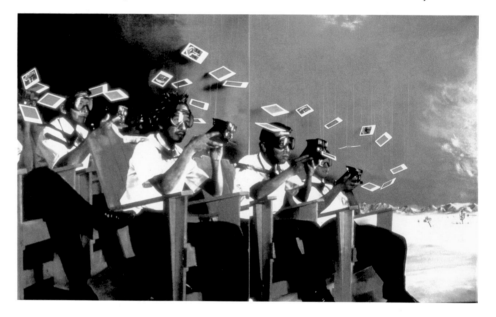

finny figures could be read as representatives of the repressed id, coming back to the surface of consciousness to demand its due—or in social terms, of any excluded Other reclaiming its rightful cultural place.

The photograph, with Nagatani as Daddy/Depicter, simply adds one more layer to the multiple meanings suggested by the setup. As in much of Nagatani and Tracey's work, the title of this piece focuses the meaning, and at the same time puns in several directions at once. "Great Yellow Father" is a familiar mocking sobriquet for Kodak, and thus the phrase (and the piece) could be taken as a reference to picture-making, or to the tendency to substitute the act of making a picture for direct experience. But Nagatani and Tracey have consistently layered in references to race in their work, and so the title takes on yet another, albeit ambiguous, level of significance.

Nuclear issues, race, and representation are the primary ingredients which

the pair mixes together in varying proportions, always lacing the results with hefty dollops of humor. In *Alamogordo Blues,* 1986, for example, a group of figures wearing protective goggles are seated in lawn chairs, facing an offscreen blast, in a pose recalling news photos of observers at early atomic tests; updating this iconic scene—etched into our consciousness as a symbol of the innocent enthusiasm that atomic blasts once evoked—is the fact that everyone in the

picture holds a Polaroid SX-70, and SX-70 prints swirl around the scene.

Nagatani and Tracey maintain a delicate balance in their work between humor and seriousness, didacticism and playfulness. There's a strong strain of Surrealism in Nagatani and Tracey's images, perhaps reflecting the compulsions and fears, as well as the apocalyptic yearning, behind much of the seeming logic of postwar nuclear strategy. But Nagatani and Tracey aim at a number of targets, combining cultural analysis, polemical statements, and slapstick, in scenes that are simultaneously amusing and annoying. That's not a bad blend, given a global political situation that in recent decades has often seemed so frighteningly absurd as to become laughable. Cracking their pointed jokes on the brink of the abyss, Tracey and Nagatani may be appropriate jesters for an apocalyptic age.